Judith Joy Ross

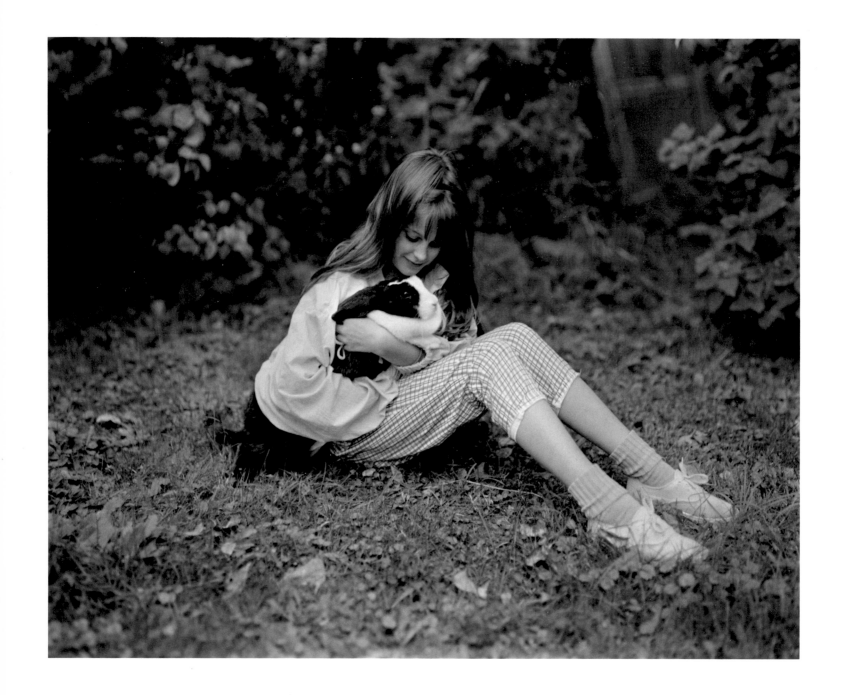

Judith Joy Ross

Essay by Susan Kismaric

The Museum of Modern Art, New York

Distributed by Harry N. Abrams, Inc.

Contemporaries: A Photography Series is made possible in part by a generous grant from CameraWorks, Inc. Additional support has been provided by the John Szarkowski Publications Fund, The Contemporary Arts Council and The Junior Associates of The Museum of Modern Art, and individual donors.

Produced by the Department of Publications
The Museum of Modern Art, New York
Osa Brown, Director of Publications
Edited by Christine Liotta
Designed by Jody Hanson
Production by Marc Sapir
Halftone photography by Robert J. Hennessey
Printed and bound by Amilcare Pizzi, S.p.A., Milan

Published by The Museum of Modern Art, New York
11 West 53 Street
New York, New York 10019

Distributed in the United States and Canada by
Harry N. Abrams, Inc., New York. A Times Mirror Company

Distributed outside the United States and Canada by
Thames and Hudson, Ltd. London

Printed in Italy

Frontispiece: *Katie Ross with her Rabbit, Godzilla.* 1990

You see yourself clearly only when you see yourself as a stranger. [1]

Susan Kismaric

The fidelity of Judith Ross's descriptions of her subjects—to the surfaces of their bodies and to their postures and gestures—is rendered through the careful drawing of the 8-by-10-inch negative. In combination with her acute description of her subject's psychological state, and her choice to photograph each person floating freely in an indeterminate, often unspecified space, Ross portrays nothing less than our common existential condition—that often terrible psychological sense of being alone in an indifferent world, and having to create meaning for our lives.

The understanding attentiveness and synchronous trust between photographer and subject in Ross's portraits allow each person's individuality and his or her inherent value as a human being to be considered. Most of her subjects, from the children in Eurana Park, Pennsylvania, to the members of the United States Congress, are pictured in their environment, on the territory with which they feel most familiar and comfortable. By bringing our attention to ordinary individual lives, she draws us toward, and into, those lives. She provokes us to think about these people as part of society. When one looks over the range of subjects in Ross's work, school children in urban and rural environments, visitors to the Vietnam Veterans Memorial, U.S. Congressmen and women, workers, members of the National Guard, all individuals in their own right, one also sees a cross-section of our contemporary American society. Like August Sander, who methodically documented German society during the first half of the twentieth century, Judith Ross, following her instinctive emotional direction, seeks to understand the struggle that each of us must face in a society where traditional values—after the assassinations, after the Vietnam War—have changed. Ultimately, she asks us to consider the often painful tension between the public and private self. Not only the tension we feel socially in relation to our peers, but also the tension each individual feels in the attempt to realize his or her potential in an often indifferent, hostile, and increasingly complex social fabric. She demonstrates how we learn, some of us more successfully than others, to accommodate other people and compromise ourselves as we grow older.

The first question to ask about a portrait is, of course, how true it appears to be in depicting a pertinent aspect of the person photographed, or perhaps more ambitiously, how accurate the portrait is in describing the supposed *true* character of the subject. The more interesting, and

undoubtedly more complicated, question one might ask in the study of portraits is how much of the artist appears in the picture. If the portrait photograph is a competition between photographer and subject in which each tries to impose himself, the artistic danger for the photographer is that the subject will win hands down, with the resulting image simply a projection of who the subject would like the world to think he is. It requires exceptional intelligence and great emotional fortitude to respond to each person one encounters without prejudice and preconception. Conversely, if the photographer wins, the resulting portrait can often be one-dimensional, with the photographer responding less to the individual subject and more to a fixed, intellectualized notion about the genre of portrait photography that often expresses itself in an overdetermined photographic formula. For all of its style and bravado, the work of Richard Avedon, for example, tends to treat each of the individuals before his camera as neurotic and dying, as if we all have had the same experience.

The ideal, of course, is that there is a match of sorts, a balance in which it is the responsibility of the photographer to instill a sense of trust in the subject, and simultaneously to identify something in the subject that is authentic. The trust can come about in a matter of minutes or over an extended period of time, as it sometimes did in the work of Diane Arbus, but it depends directly on the subject's level of interest in the process of having his picture made. The subject is interested if he believes the photographer is interested in him.

The photograph of the gas station attendant (page 53) is part of an unfinished project in which Ross photographed people at work, and is an example of the complexity she often achieves in her pictures. "Mike" appears to be a man who has led something of a hard life, most likely outdoors; he is a physical man who does physical labor. There is sadness in his face, but also a trace of kindness and a touch of geniality in his eyes. The lines in his face lead us to imagine his past, but we cannot veer from the moment, from the man standing before the camera in the instant the picture was made. Finally, we wonder what will become of this man.

Judith Ross works with old-fashioned equipment, an 8-by-10-inch view camera on a tripod similar to the kind used by photographers a century or more ago. She only makes printing-out paper prints, also in use from the beginnings of photography. The printing-out paper print requires an arcane process: a contact print is made without an enlarger by placing a negative on photographic paper, and then exposing it to sunlight for a few minutes to a few hours. The prints are then toned with gold to bring out warm brown and gray tones. The technique achieves absolute fidelity to the original drawing of the negative and an exquisite, transitory luminosity that seems to suspend time, gently forcing the viewer to understand how each moment in our lives should be acknowledged.

Ross often speaks of the magic of photography. What she means by this is how the camera does much of the work in making a picture. Like the nineteenth-century portrait daguerreotypists Albert Sands Southworth and Josiah Johnson Hawes, and the later German portrait photographer August Sander—for whom Ross has expressed great admiration—her approach is to simply center her subject in the frame. She relies on the fidelity of photography and, when possible, natural light to describe what is before the camera. What transpires between her and her subject during the making of a picture is, of course, the most important thing.

The most significant contemporary antecedent to Ross's portraits is Diane Arbus's work of the 1960s. Using the technique of the police photographer, the flash of her camera illuminated a population previously considered unworthy photographic subject matter, except for the most exploitative reasons. The majority of subjects in Arbus's portraits are people on the fringes of society: transvestites, drag queens, circus performers, nudists, midgets, dwarfs, giants, people Arbus referred to as "freaks." There had been no portraits like Arbus's in the history of photography. No one had paid attention to the people she sought, or accorded them the dignity that she did. In her work Arbus pursued the extreme as a way of breaking away from her conventional, privileged upbringing and finding herself. She pursued and accepted individuals who had arrived at a kind of self-declaration, a "coming out" of the parts of themselves that society had defined as aberrant. Unlike Arbus, who seemed to embrace only the aberrant qualities of her subjects, Ross searches for a reconciliation between our vulnerable and powerful selves, our innocence and cynicism, and our humane and inhumane tendencies. While the pursuit of self through photography is common to both artists, it is only the unfailing sense of trust between subject and photographer in the two bodies of work that is similar.

I once had the opportunity to observe Ross making a photograph. We had been driving through the streets of Minersville, a small, former coal mining town in eastern Pennsylvania, when Ross suddenly asked me with excitement, "Did you see that kid's face?"[2] Not having seen a kid at all, I replied, "No." Ross responded by saying it was "beautiful, just beautiful." She suddenly stopped the car and was at the trunk pulling out her unwieldy 8-by-10-inch camera and tripod, calling after two twelve- or thirteen-year-old boys, "Hey guys, hey guys. . . . Do you mind if I take your picture?" Upon seeing the old 8-by-10-inch camera, they were mesmerized. After shuffling their feet for a few seconds, they looked at each other, shrugged their shoulders, and agreed to be photographed. I could see that they were flattered by Ross's attention and her continuous exclamations of genuine appreciation.

Within a minute Ross had made the first exposure. While she changed the film, the boys began to straighten their shirts, pat down their hair, and eye each other quizzically to be sure they looked presentable. What was wonderful about the moment was how quickly Ross had seen what she wanted, and how effortlessly she had convinced the boys to be photographed. The face of one of the boys was not only truly physically beautiful, but also bore an expression of pure innocence. Seen in relation to his less handsome, shorter, and slightly less trusting friend, one could sense that the potential photograph would contrast the two youths. The picture could raise questions about the experience of the boys as determined by their physical appearance. Ross had achieved the picture through sheer instinct and passion.

· · ·

Judith Joy Ross was born in the small town of Hazleton, Pennsylvania, in 1946. As a child she learned to appreciate art primarily through music. Both her parents played classical piano and her mother, who had studied at Juilliard, taught piano to neighborhood children. Ross remembers a house filled with music that created a romantic atmosphere. She also drew as a child and imagined herself an artist. Her earliest efforts as a photographer were the childhood photographs she made of squirrels with a Kodak Brownie

camera, with unsatisfying results. The discrepancy between what she saw and the scratchy, blurry, virtually unreadable patches of gray was demoralizing and put her off the medium for the next ten years.

Ross talks about her formal education as a photographer with candor and a sense of humor. She studied art education at the Moore College of Art in Philadelphia where she received an undergraduate degree. While at Moore it began to dawn on her that she had little talent for drawing. She took a photography class and fell in love with the medium. She used a $2^1/_4$-inch format camera to photograph her family and when the results *were* close to what she had seen, she was hooked on photography's capacity to describe the world, its ability, as Ross puts it, to be so "intensely present." She was thrilled with how photography, more than any other medium, conveys "how amazing reality is." Ross went on to obtain a master's degree in photography from the Institute of Design in Chicago, Illinois, under the tutelage of Aaron Siskind. In retrospect, the choice of the Institute was somewhat ironic for a photographer whose work was grounded in instinct rather than intellect. The Institute had been founded in 1939 as the New Bauhaus, a derivation of the original Bauhaus in Germany, where experimentation in photographic technique in conjunction with the study of the other plastic arts was focused. The work of the teachers and students of the New Bauhaus—Siskind, Harry Callahan, and Art Sinsabaugh most prominent among them—deployed an austere formalist technique that was resolutely aesthetic in its purposes. Ross's photographs, on the other hand, are so natural in technique, that they appear to be without aesthetic formula, transparent to the subject.

Ross describes her years in graduate school, from 1968 to 1970, as a kind of blur, spent mostly in Chicago's Clark movie theater as a way of avoiding class. She recalls two significant bodies of work that she produced during that period that relate to her later photographs. The first was of furniture in a junk shop, organized in the pictures to simulate the physical formations of human relationships. In one image, two stuffed chairs were framed as though they were conversing. To Ross, the pictures functioned as metaphors. The second group were pictures of people seen from behind, in which Ross had people turn around so she could photograph the backs of their heads, essentially the exact opposite of her mature work. After graduation, she went on to teach photography for fourteen years at a small college in Pennsylvania.

Ross says that she left graduate school a "lost soul." At the outset of her artistic independence, the photographic community was just beginning to define itself as a contemporary art force. In the absence of a supportive environment, Ross instinctively gravitated toward those photographers whose work spoke directly to her—Eugène Atget, August Sander, and Diane Arbus—through books. The extent of Ross's alienation from the photographic environment of the period is demonstrated by the following anecdote. One day, while visiting a New York City bookstore, she spotted a poster announcing an exhibition of Sander's work with reproductions of photographs from his series *Men of the Twentieth Century*. In her determined way, Ross persuaded the manager to remove it from the wall and give it to her on the spot. Whether an inspiration or a reference against which she could measure her own progress, the pictures reproduced on the poster remained an artistic model for her own photographic ambitions.

For several years, Ross worked in a haphazard way, mostly making photographs of people framed by her camera so that their heads were cropped out of the image. She felt that she

had stopped trusting her judgment about what a picture might be, and that she was repeating pictures she had already made. In 1976, a colleague gave her a broken 5-by-7-inch view camera which Ross used with a wide-angle lens. She found it thrilling to look through, seeing what she described as "a kind of magical and metaphorical world of tiny people in environments." In 1977 she used the same camera with a shutterless, nineteenth-century lens to photograph the objects and displays in her father's failing five-and-ten-cent store for "memory's sake," making "gentle, accepting pictures about loss." The shutterless lens had a shallow depth of field which brought the objects closer to the viewer. The resulting picture was nearly circular because the image the lens projected onto the 5-by-7-inch plate did not completely cover it. The circular image acted as a kind of eye, with a gradual falling off of focus around the outer edges. According to Ross, looking at the image created by the lens was like looking through a tube; it helped her focus more directly on the world in front of her. In 1976 and 1978 Ross traveled to Europe where she began to experience a turning point in her work, making pictures that anticipated the pictures she makes today, and in which she began to recognize certain qualities that she wanted to and could repeat. She describes this recognition as her reconnecting with the world by simply seeing and accepting what is there, rather than trying to make photographs. She recalls one picture in particular, a photograph she took in Pisa, Italy, of three men leaning out the window of a hospital and how she simply let the camera draw what was before it.

In 1981, Ross bought an 8-by-10-inch view camera. In so doing, she found the camera format that nineteenth-century practitioners had used and the one that liberated her to face her subjects in the most direct way possible. In an essay about her work, the photographer Robert Adams wrote: "Judith Ross has, as an artist, no formula. She starts over again each time—the riskiest way to do it. She has a style, of course, but it is austere. It cannot, if she panics, be used to take the place of content. . . . Ross's method promotes this clarity: she uses a view camera, which because of its size makes openness necessary in dealing with people."[3]

It was not until 1982, when she photographed children in Weatherly, Pennsylvania, that she began to feel she was truly becoming a photographer. At the age of thirty-five, the emotional pain she experienced when her father died drew her back to her childhood experiences. But as Ross has said, "There was no one there to photograph." She went to Eurana Park, a small public swimming park in Weatherly located a few miles from her family's cottage where she had spent her summers from the time of her birth. As a child, the cottage, and the flora and fauna and insect and animal life of the surrounding wood became a special world for Ross, one in which she felt safe while she observed the habits and lives of animals, and the variations of plant life. With her parents and her brothers, Robert and Edward, she spent hours searching for tadpoles and salamanders or waiting for a deer to appear at the edge of the wood at dusk. Her fastidious observation of the smallest of creatures and plants would later express itself in the careful attention she would devote to observing people.

Feeling the pain of her father's death, Ross was drawn to the life of children in Eurana Park, to their asexual innocence and vulnerability. She had been spending time with her two young nieces, Katie and Cali, the first children with whom she had a personal relationship, and she was enthralled by their curiosity and the joy with which they greeted the world. Ross describes the park,

to which children can walk from their homes unaccompanied by adults, as a kind of fantasy, a Brigadoon. At Eurana Park, children freely express themselves in the physical and sensuous pleasures of swimming, sunning, and playing in the woods. Ross's instinct to overcome her grief at the loss of her father by photographing children proved on target when she made the picture of three little girls with popsicles (page 24). She describes the photograph as the answer to her question, "Why is life worth living?" She remembers the three girls as so utterly open to the picture-making session that she could barely contain her excitement. She found them perfect—beautiful. As they mumbled their telephone numbers so Ross could send them prints, she lowered the tripod of her camera to their eye level, the first time she made a picture from that height. Figuratively and literally, she was seeing the world from a child's perspective.

The range of experience of the children in the Eurana Park series does not extend very far. At the most, these children are beginning to feel the discomfort of their bodies. None have tipped over the precipice of adolescence, into socialization, into knowing what to wear and how to project themselves. The photographs in the project document childhood and its innocence. Children would continue to be a photographic subject for Ross for the coming years, acting as a muse for both her art and her life. In their innocence, she would find a salvation against the suffering and pain of life.

· · ·

Knowing that the lives of children are relieved of complexity because of a lack of experience, Ross knew it was essential for her growth as an artist to photograph adults. Indeed, the children she photographed would one day *be* adults. In a sense, the artistic challenge represented for Ross a further confrontation with herself, with the adult she was becoming. Her photographs of adults describe the passage of time, the accrual of defenses, the brandishing of postures, and the humanity and vulnerability that remains in each of us as we age. The pain of her father's death was still with her so that photographing adults, people who may have experienced a loss through death, might help her explore further her questions about the meaning of life.

While Ross's choice of subjects is always part of a conscious effort at understanding and defining herself and is rooted in her emotional life, her social conscience is an integral part of her effort. While her work is never overtly political, she has periodically chosen projects that are concerned with political topics—visitors to the Vietnam Veterans Memorial in Washington, D.C., portraits of members of the United States Congress, and soldiers going off to fight in the Gulf War. By locating these potentially "political" themes in portraits of individuals, she brings home the issues of war and political responsibility to the private citizen. Through her efforts in these series, we gain a sense of how our political lives and the decisions of those we elect to lead us take a toll on other aspects of our beings. In her photographs, the young people going off to war have clearly been caught up in an event beyond the scope of their daily lives and dreams. The visitors to the Vietnam Veterans Memorial relive or retrospectively experience the horrific consequence of the ultimate political act, and our United States Congressmen and women stand vulnerable before the camera, no more in command than we.

The question to the viewer consistently raised by Ross's work is one about the mea-

sures of personal responsibility, not only by the portraits in these "political" series, but especially in her pictures of children. Since children are a population whose important decisions are made for them, we are all responsible on the most personal level.

In 1983, after hearing about the installation of Maya Lin's memorial to the veterans of the Vietnam War on the radio, she went to Washington, D.C., to photograph its visitors. The site of the black granite wall, inscribed with the names of those who died in the Vietnam War, had quickly become the repository for the nation's collective grief and suffering about the war, and the place where individual mourners came to confront the meaning of the loss of loved ones. Ross imagined herself to be doing a project about America and the war, a project in which citizens from all parts of the country, all social classes, and many races would be represented. Instead, the deeply felt experience of the visitors to the wall, no matter their social status or origins, became the subject. The faces in these pictures embody grief, sometimes confusion, but always a willingness to surrender to the sadness of the place and the seriousness of its meaning.

Four years later, in 1987, Ross was struck by her inability to comprehend how our political leaders explained world events on television. It was the time of the Iran-Contra hearings and the testimony of Oliver North, the wars in El Salvador and Afghanistan. To Ross, the people who appeared before the television cameras seemed mechanical and removed, somewhat inhuman. Being politicians, they were sophisticated in how they presented themselves to the media, and they did not want to appear unsure and somewhat vulnerable. Since these were the people who were making major decisions that directly affected Ross's life, she thought she might begin to know better who these people were by photographing them. Ross, who lives in Pennsylvania, contacted the Pennsylvania Academy of the Fine Arts in Philadelphia and suggested that a photographic project of portraits of members of Congress would be an appropriate exhibition for the Academy to hold in celebration of the 200th anniversary of the United States Constitution. Using the potential exhibition as a reason for the Congressmen to grant her request to photograph them, and with financial support from the John Simon Guggenheim Memorial Foundation, Ross undertook a vigorous and tenacious campaign of letter writing and telephone calls. She managed to set up appointments with 117 Congressmen and women, and forty-two of their aides.

While she had imagined that the characters who had daily appeared on her television set would live up to her prejudices and opinions, Ross was greatly relieved to find that they did not. Nevertheless, her work was done under the most demanding circumstances. Each portrait session was restricted to fifteen minutes, during which time Ross had to set up her camera, make the portrait, and leave. For Ross, photographing some of the most powerful people in the country made the brief encounters intense. She prepared herself by reading the voting records of each of her subjects. To her surprise, she met very human beings who often expressed qualities their public personas did not suggest. She was, however, met with occasional rudeness and indifference, and this seems to be what she sometimes responded to. One does detect a hint of caricature in several of the portraits, especially in those of Senator Robert Byrd and Congressman John P. Hiler (pages 45 and 42), the result, perhaps, of a kind of lopsided balance of power between the photographer and her subject.

In a sense, moving from the Eurana Park project, to photographing people at the Vietnam Veterans Memorial, to photographing members of Congress, represented an escalation of sorts, a progression from the least sophisticated segment of the population to the most hard-boiled. The fact that she was able retrieve any sign of humanity at all in her portraits of a crusty, beleaguered Congress attests to her extraordinary instincts and abilities as a photographer.

In 1988 Ross received a grant from the city of Easton, Pennsylvania, to create a work of art in a public space. After photographing the members of Congress, Ross had little energy left for another particularly challenging project, so she returned to the subject with which she felt most comfortable—children. Her idea for the project was focused on what way the photographs might best serve her subjects and audience; how they might raise our consciousness about the value of all children. Ross decided to secure the Easton YWCA as an exhibition site, and to make photographs of the children of Easton which she would print on 20-by-24-inch paper for the installation, a print size she had never used before. In this way, the people who frequented the Y—those taking classes, as well as the homeless women and children who were allowed to live on the top floor—could not avoid the photographs, and would, perhaps, casually get her message as they walked through the lobby. Ross hoped to make pictures that would present an "anti-Barbie and Ken doll" message, one in which a child or adult could understand that even if he or she didn't look like Ken or Barbie, they were wonderful for simply being who they were.

The photographs of the children in Eurana Park were unified by the activity of swimming and the specificity of a small locale, while the children on the streets of Easton were not. Ross found that she could wander the streets and not see a child for long stretches of time, then she would come across one, and within minutes a dozen more would gather. The children she encountered in Easton were also different from those in Eurana Park because they were city kids. Additionally, through her understanding of the profound need of Congressmen to project an image of confidence, she realized her own potential to project such an image, and was therefore able to identify in these children a self-awareness and a tendency to adopt external ideals and models. What distinguishes these children from the children of Eurana Park are their attempts to project themselves as they want to be seen. While the photographs of children in Eurana Park are pictures about the innocence and vulnerability of childhood, the photographs of Easton children are about the lives of individual children, and describe various emotional states of a racial and ethnic cross-section of the community. One can easily see the difference between the children in the Eurana Park series and those of the Easton series in the photograph of the teenage boy in a Motley Crue T-shirt, wristwatch, stone-washed jeans, and trendy haircut (page 49).

In 1990, while photographing people working at their jobs, Ross made pictures of people in uniforms. Among them were men and women serving in the National Guard, many of whom volunteered their monthly services to earn extra money. The old armory where they gathered was close to Ross's house, and when the Gulf War began in January 1991, and the soldiers were put on Red Alert, Ross ventured there to photograph the members of the Guard who had been called up to serve (see pages 54 and 55). Ross describes the atmosphere in the armory as very tense. The setting for the

pictures was almost theatrical, with the uniformed soldiers appearing "costumed," and the "stage" of the floor dramatically lit by lightbulbs mounted on the high ceiling. The soldiers were lined up to fill out forms and receive malaria shots. According to Ross, everyone wanted to be photographed, to somehow make concrete who they were before going off to an abstract, unknown future. The sense of shock the soldiers felt about having been called up was palpable, as was the fear on their faces. Ross was amazed to see women going to war, and shocked to see some of them enthusiastic about it.

In 1992, a series of personal crises led Ross to review her own past by photographing the places of her childhood. She had been thinking about photographing in schools as a way of defining something of the experience of childhood, and with funds she received from the Charles Pratt Memorial Award, she began the project. While she couldn't photograph her specific history, she could make pictures of children in the same schools she had attended in Hazleton, Pennsylvania. In preparation, she looked at the photographs of Jacob Riis and Lewis Hine and thought that she might be able to use artificial light in the schools project, in the same way that Riis and Hine had used flash powder to light the darkened alleyways and factories where children suffered abuse at the turn of the century.

Ross embarked on the project with intimate knowledge and intense memories of the classrooms and hallways she would be entering. She wanted to photograph the buildings where she had been a student during the late 1950s and 1960s, and where her mother had studied in the 1920s. The school buildings were essentially the same, with minor differences in decor—new blackboards, new desks, same linoleum—but her experience photographing in them was not unlike that of Alice in Wonderland, as when we return to places of our childhood and discover the scale and space completely different, *smaller,* than our memory of it. She describes the junior high school as "filled with the atomic energy of twelve-year-olds bouncing off the walls." Ross recalls the intense anxiety she felt when she began the project and how it helped determine the style of many of the pictures she made. Fearful of intruding, she circled her subjects and photographed them obliquely, making pictures which describe the narrative details of a typical school day. Yet while they were being photographed, these children, like their photographer, were reticent, wary of projecting their individuality. The photographs on pages 57–63 represent a highly selective version of this journey through Ross's primary school life.

In 1993 Ross was asked by the George Gund Foundation of Cleveland, Ohio, a nonprofit organization established for the purpose of "contributing to human well-being and the progress of society," to photograph children in two of Cleveland's inner-city schools. The photographs were eventually used as illustrations for the Foundation's annual report. Ross was the perfect choice for the assignment. Although familiar with children as a subject, she felt challenged by the project because she had never photographed at the behest of someone else, or made photographs of children so radically outside of her own life's experience. In many ways, the children in these pictures represent an aspect of the social spectrum that is very different from the one from which Ross had come. They are big-citied, African-American, some are members of gangs, and many are terribly deprived. The school buildings are, in fact, brand new with the most up-to-date facilities, but the students are bussed in from some of Cleveland's poorest neighborhoods. She reverted to the style of photograph-

Eurana Park, Weatherly, Pennsylvania. 1982

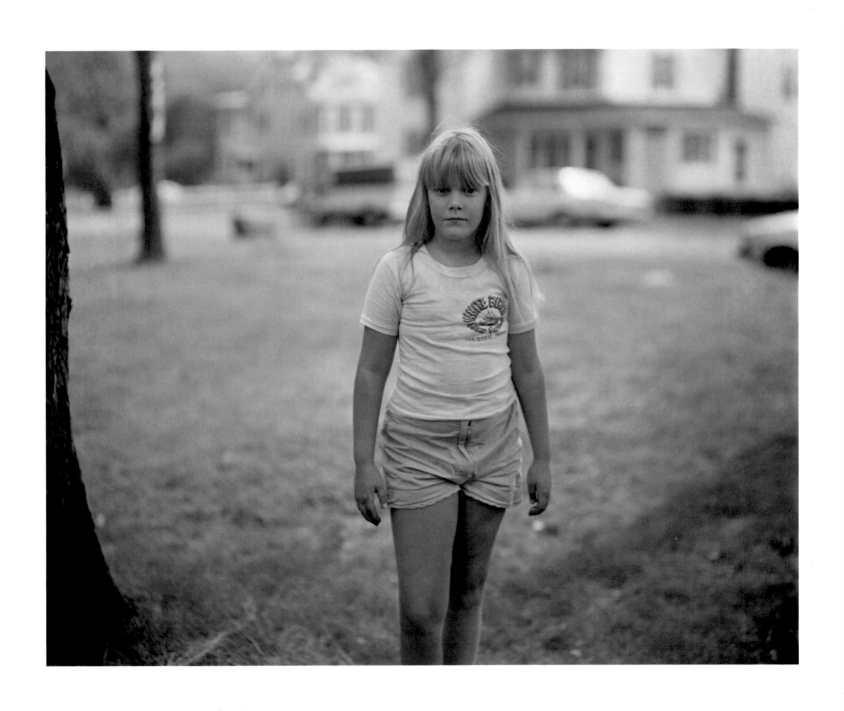

Untitled, from *Eurana Park, Weatherly, Pennsylvania.* 1982

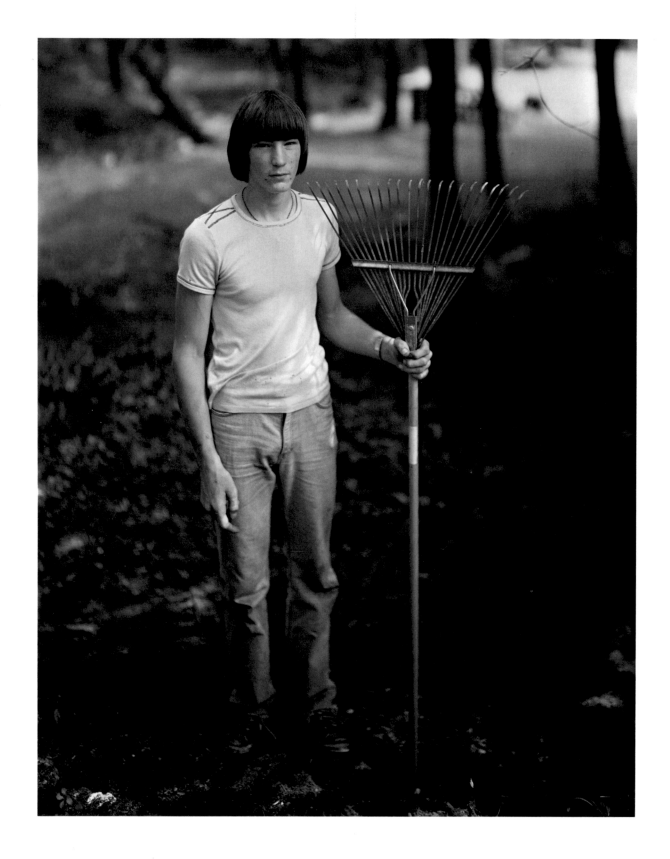

Untitled, from *Eurana Park, Weatherly, Pennsylvania*. 1982

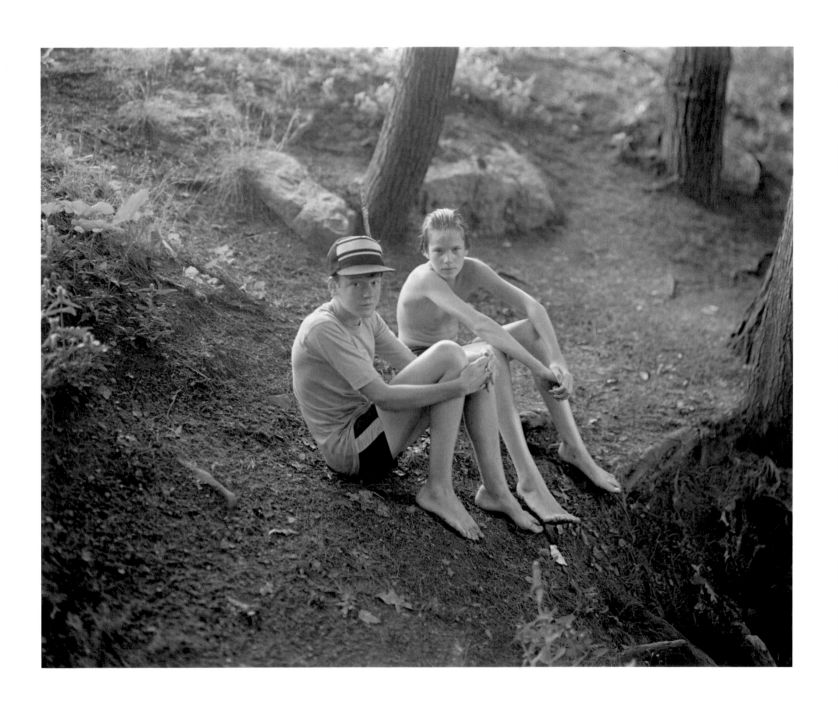

Untitled, from *Eurana Park, Weatherly, Pennsylvania.* 1982

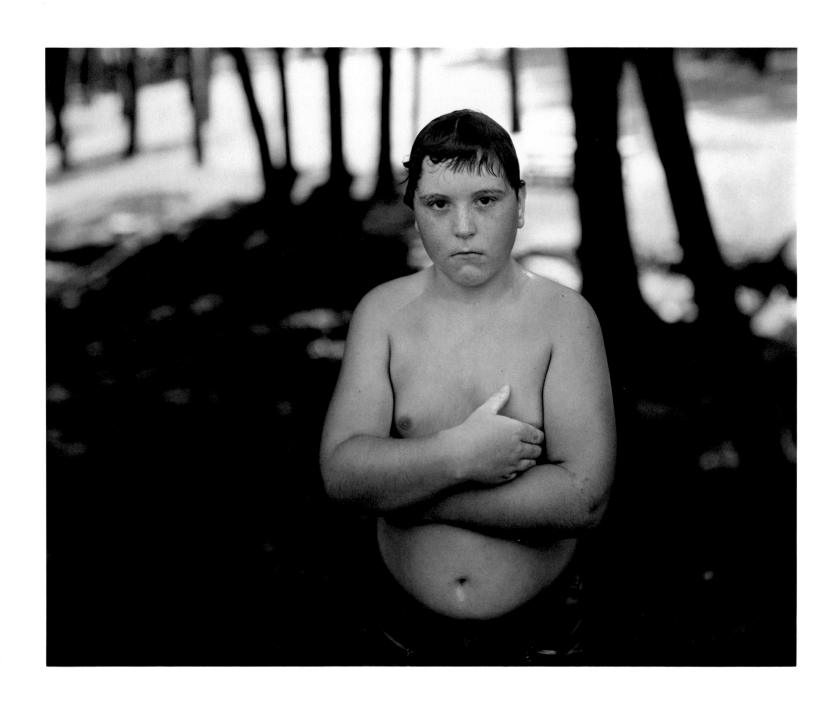

Untitled, from *Eurana Park, Weatherly, Pennsylvania.* 1982

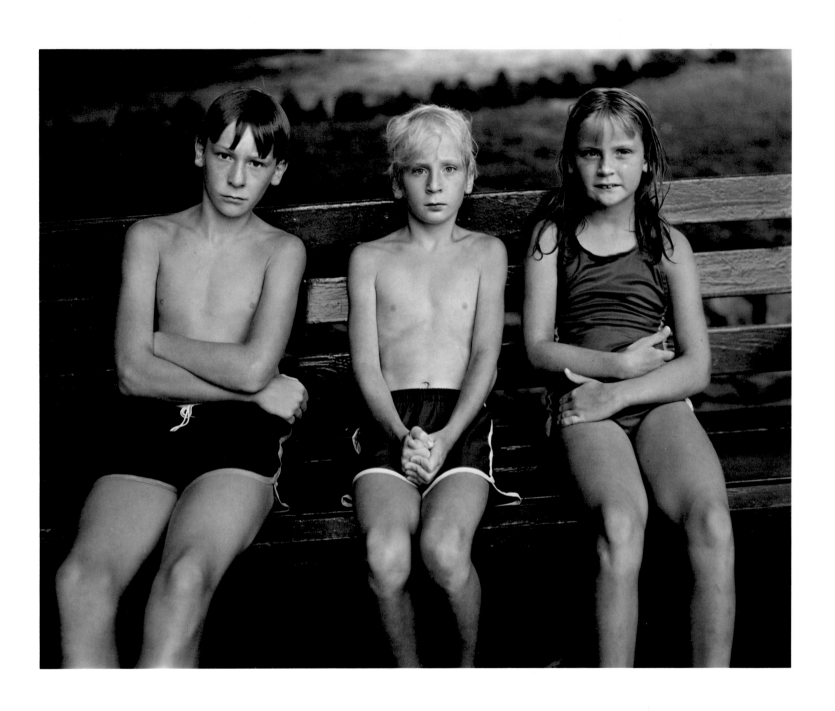

Untitled, from *Eurana Park, Weatherly, Pennsylvania.* 1982

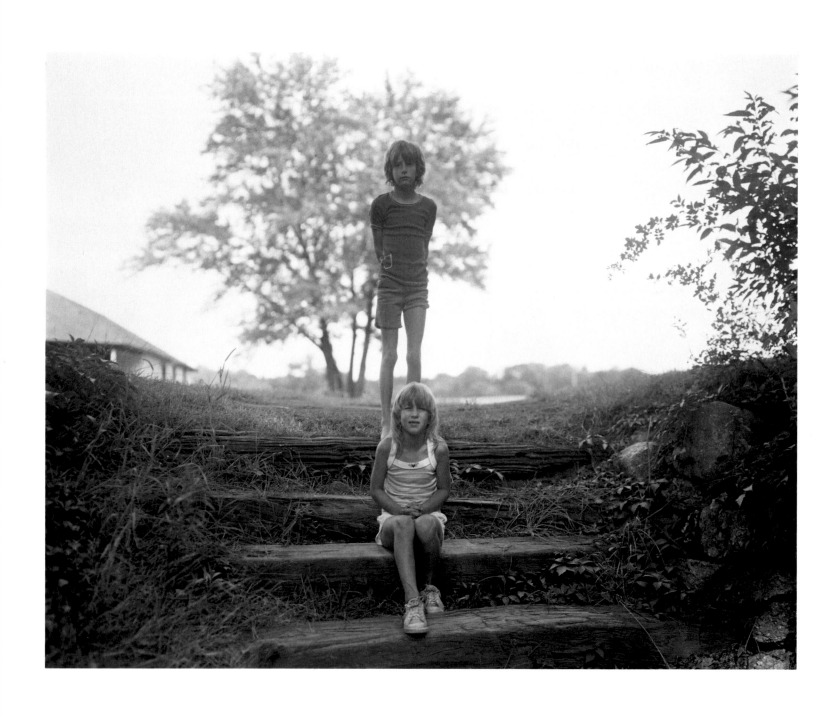

Untitled, from *Eurana Park, Weatherly, Pennsylvania.* 1982

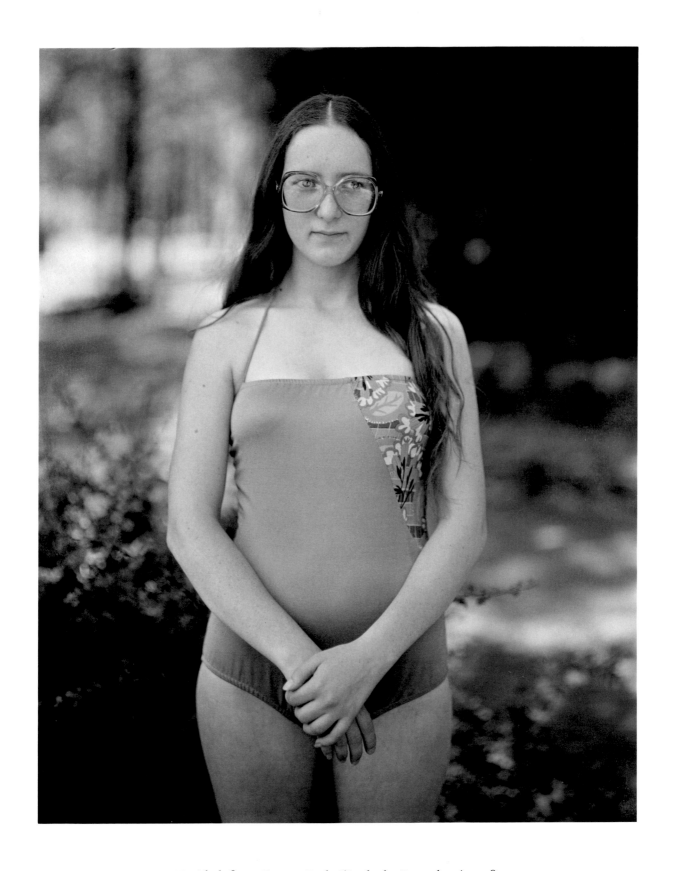

Untitled, from *Eurana Park, Weatherly, Pennsylvania*. 1982

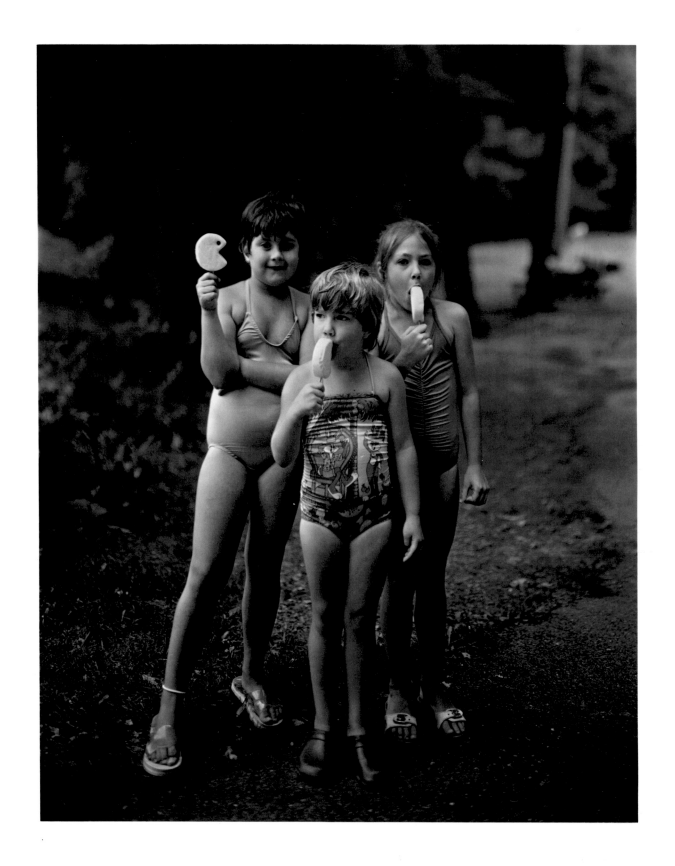

Untitled, from *Eurana Park, Weatherly, Pennsylvania.* 1982

Portraits at the Vietnam Veterans Memorial, Washington, D.C. 1983–84

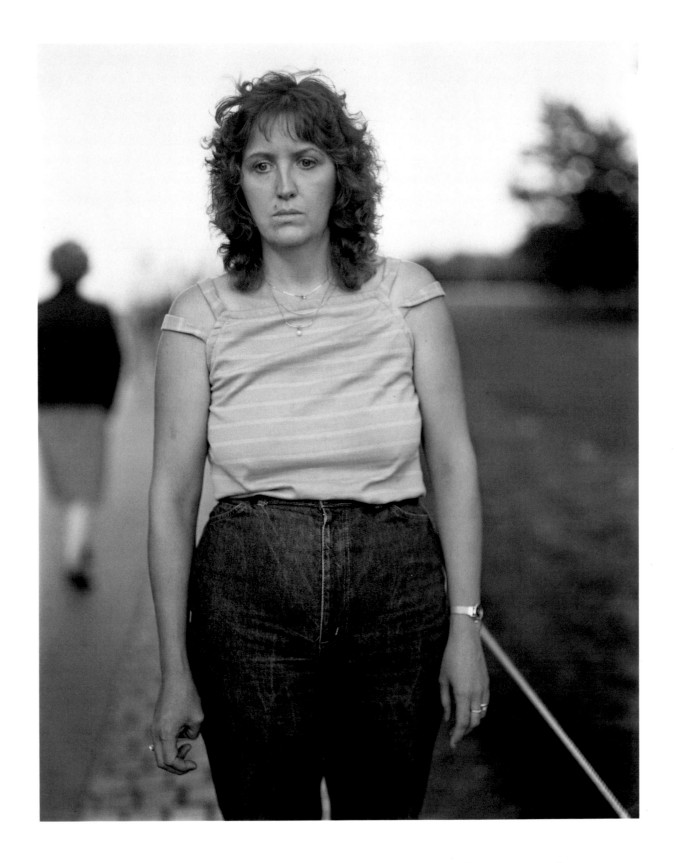

Untitled, from *Portraits at the Vietnam Veterans Memorial, Washington, D.C.* 1984

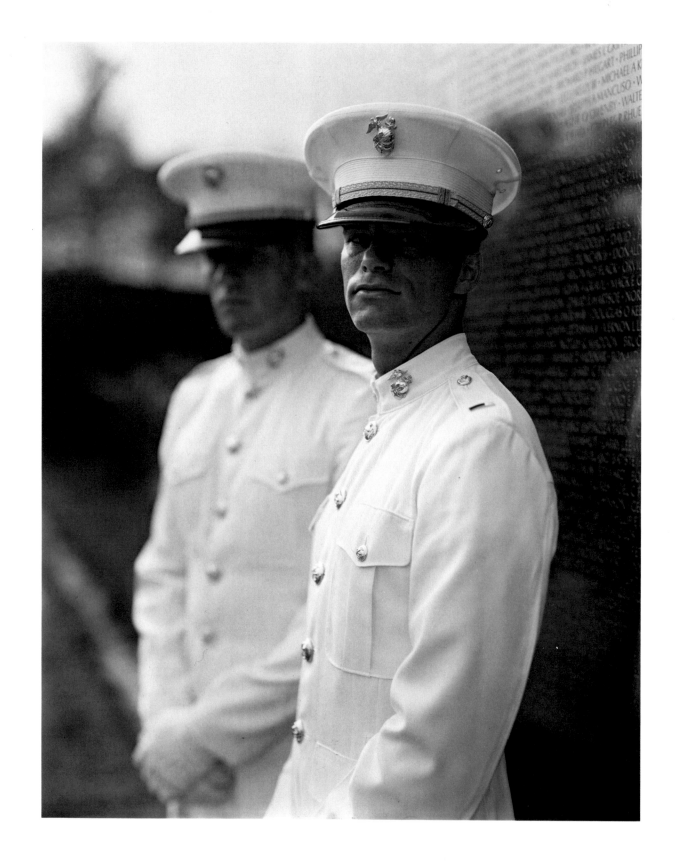

Untitled, from *Portraits at the Vietnam Veterans Memorial, Washington, D.C.* 1983

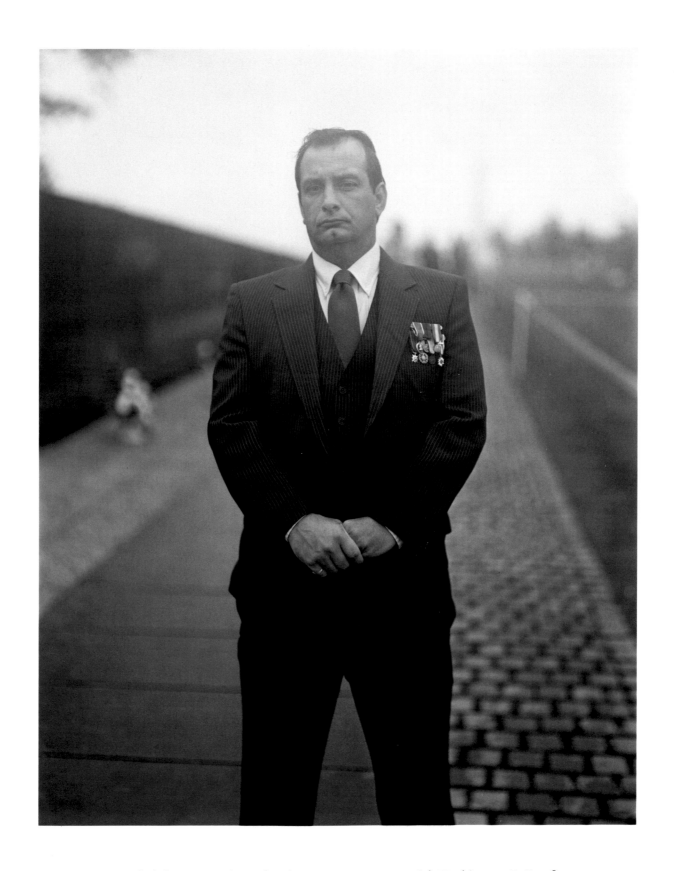

Untitled, from *Portraits at the Vietnam Veterans Memorial, Washington, D.C.* 1984

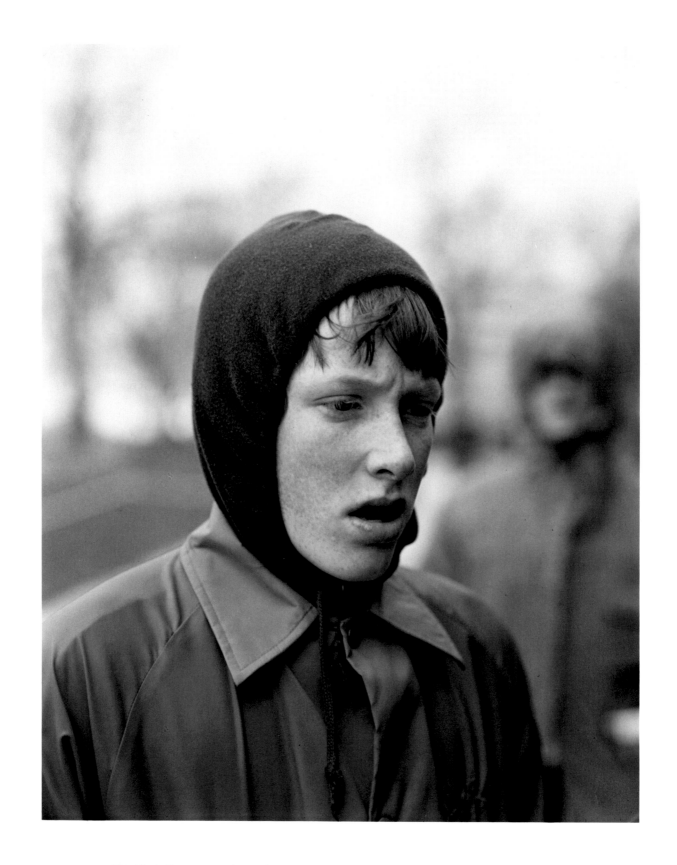

Untitled, from *Portraits at the Vietnam Veterans Memorial, Washington, D.C.* 1984

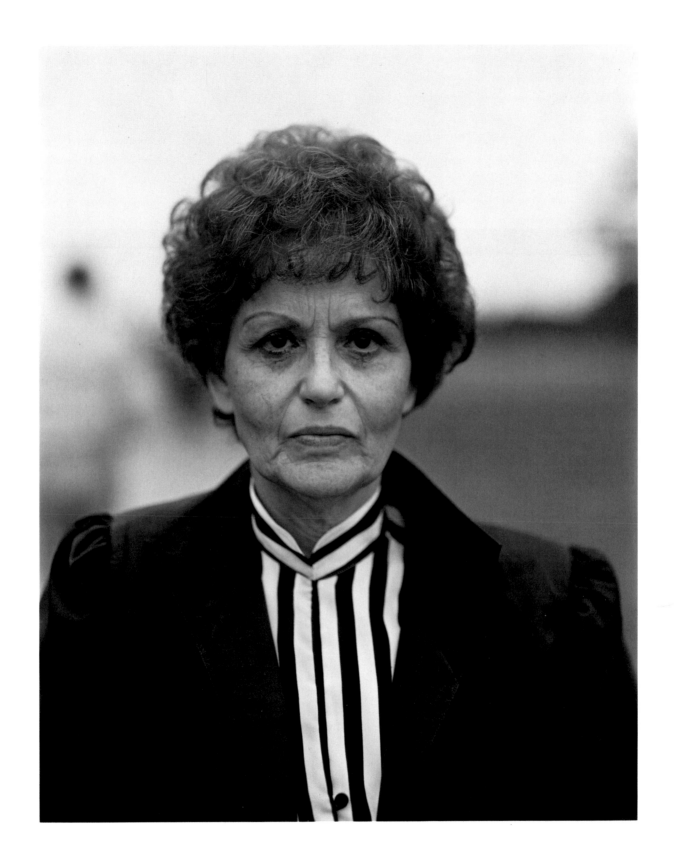

Untitled, from *Portraits at the Vietnam Veterans Memorial, Washington, D.C.* 1984

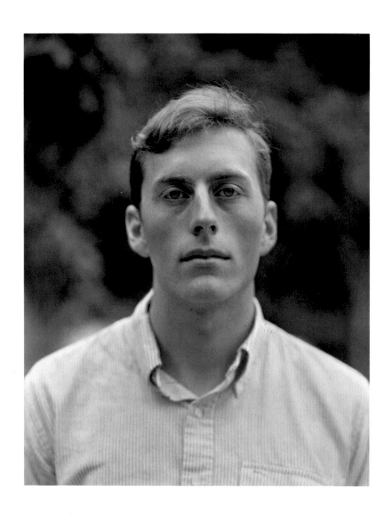 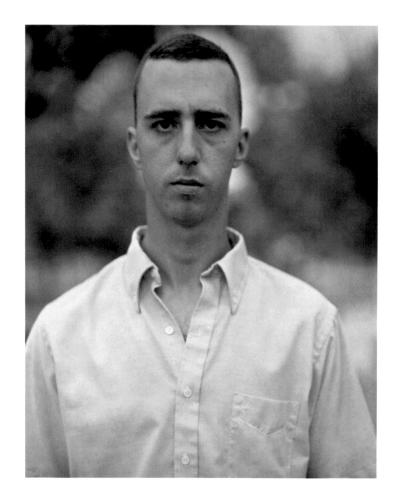

Above and opposite: Untitled, from *Portraits at the Vietnam Veterans Memorial, Washington, D.C.* 1984

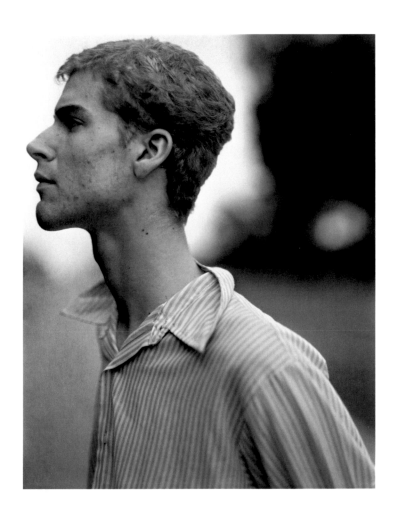
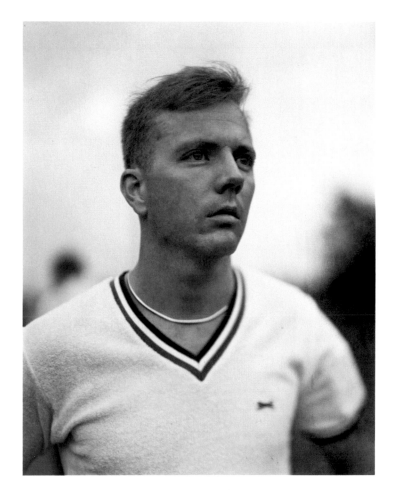

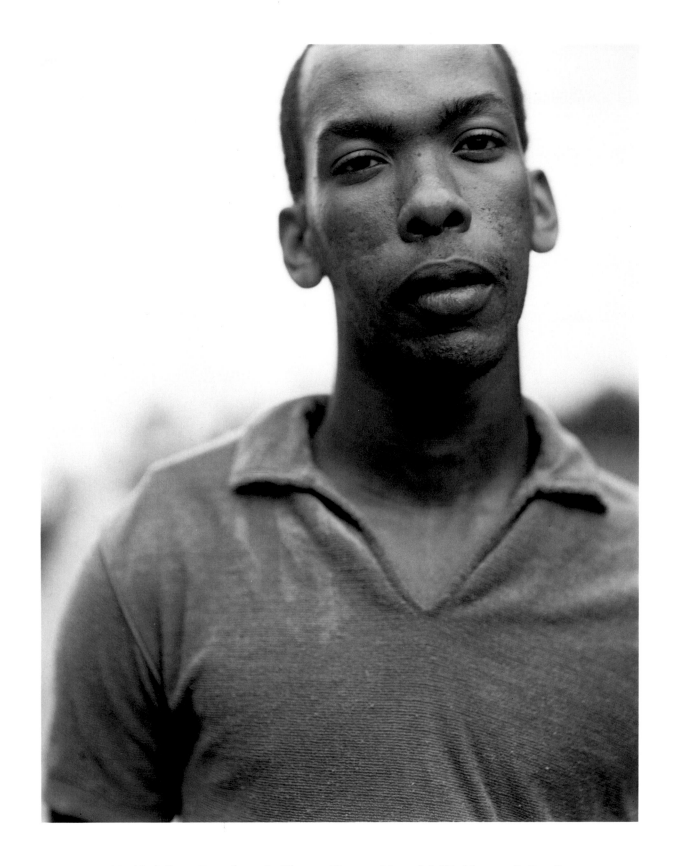

Untitled, from *Portraits at the Vietnam Veterans Memorial, Washington, D.C.* 1984

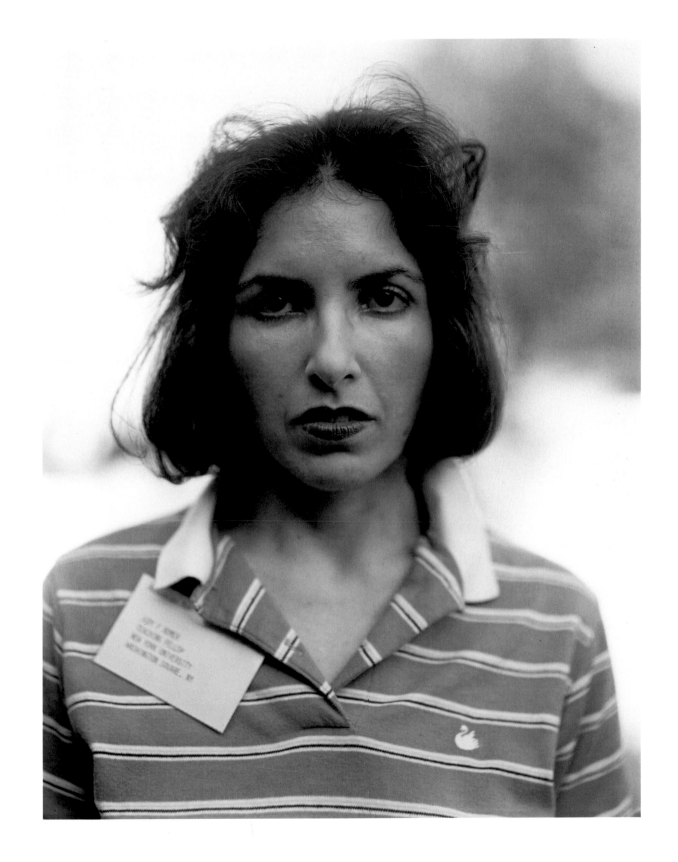

Untitled, from *Portraits at the Vietnam Veterans Memorial, Washington, D.C.* 1984

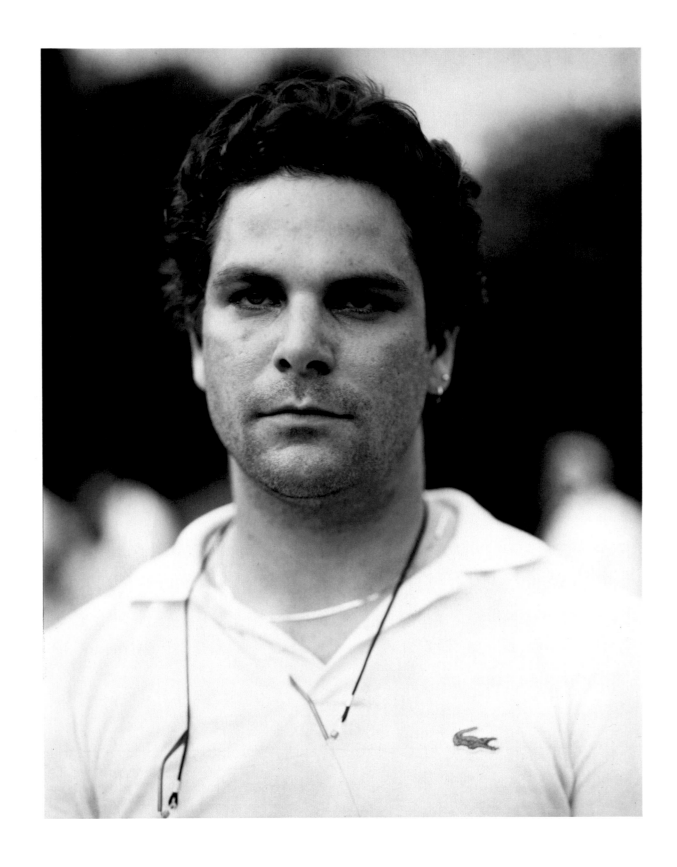

Untitled, from *Portraits at the Vietnam Veterans Memorial, Washington, D.C.* 1984

Portraits of the United States Congress. 1986–87

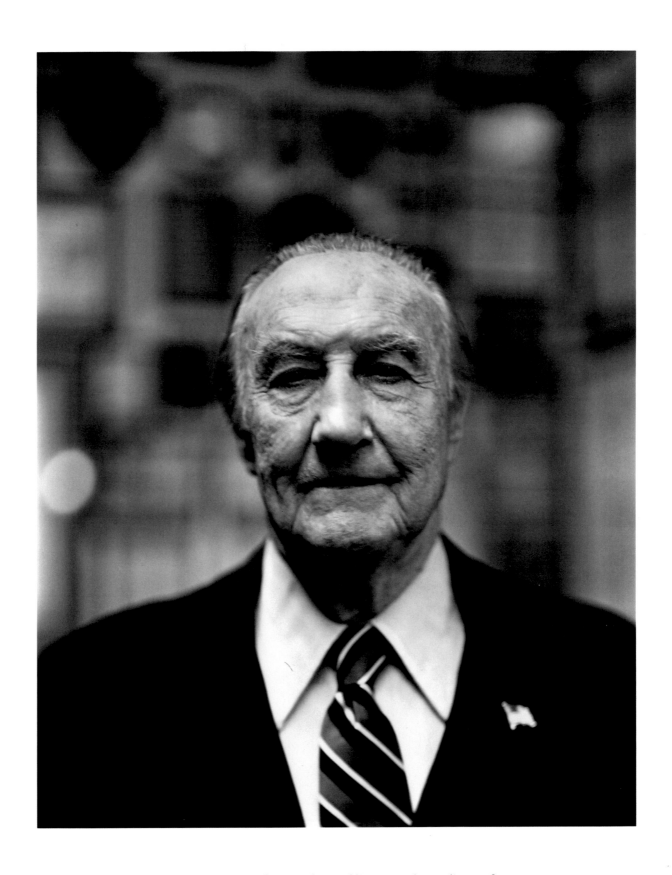

Senator Strom Thurmond, Republican, South Carolina. 1987

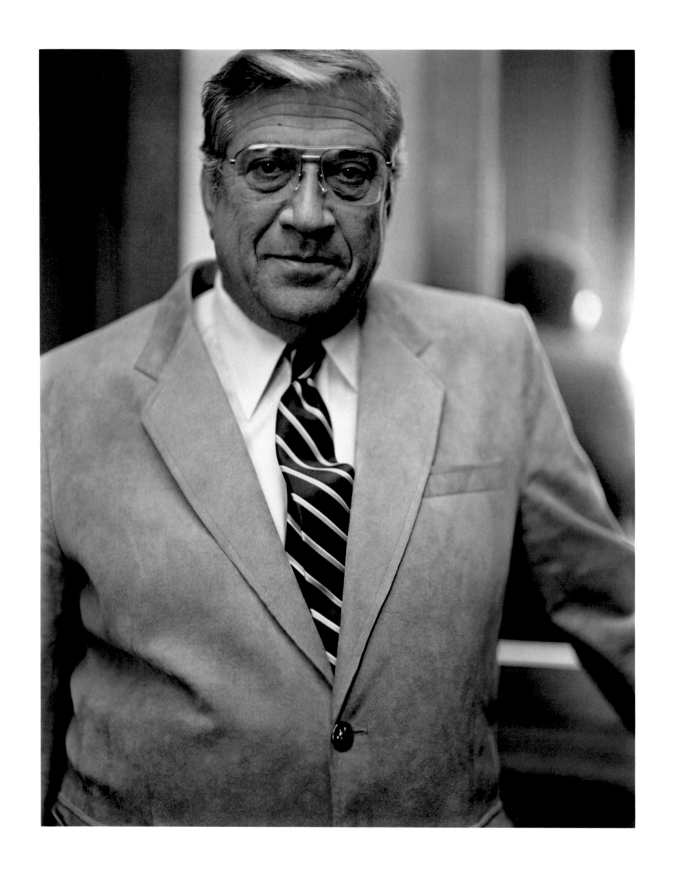

Congressman William L. Dickinson, Republican, Alabama. 1987

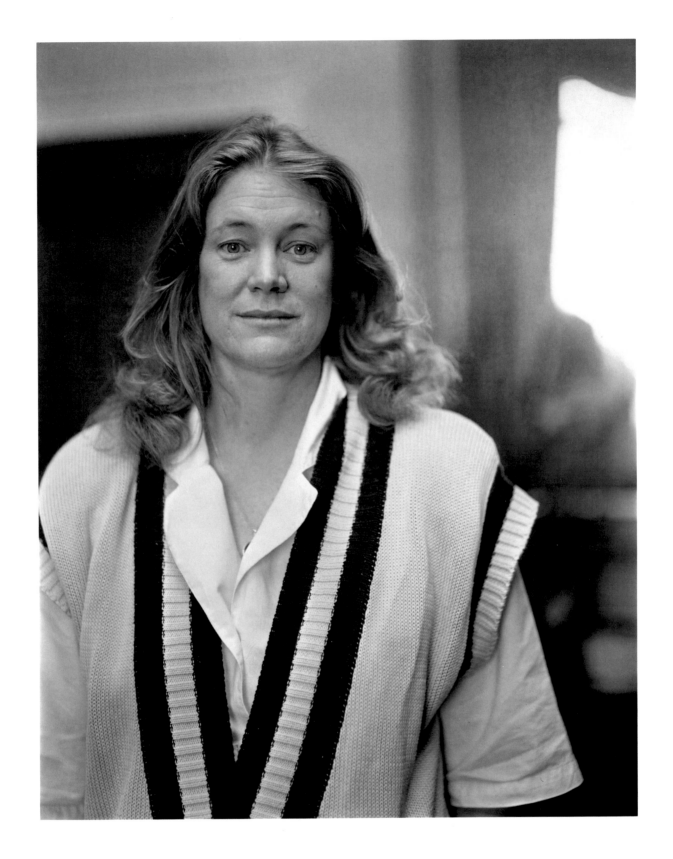

Susan Stoudt Elving, Administrative Assistant to Congressman Norman E. Mineta, Democrat, California. 1986

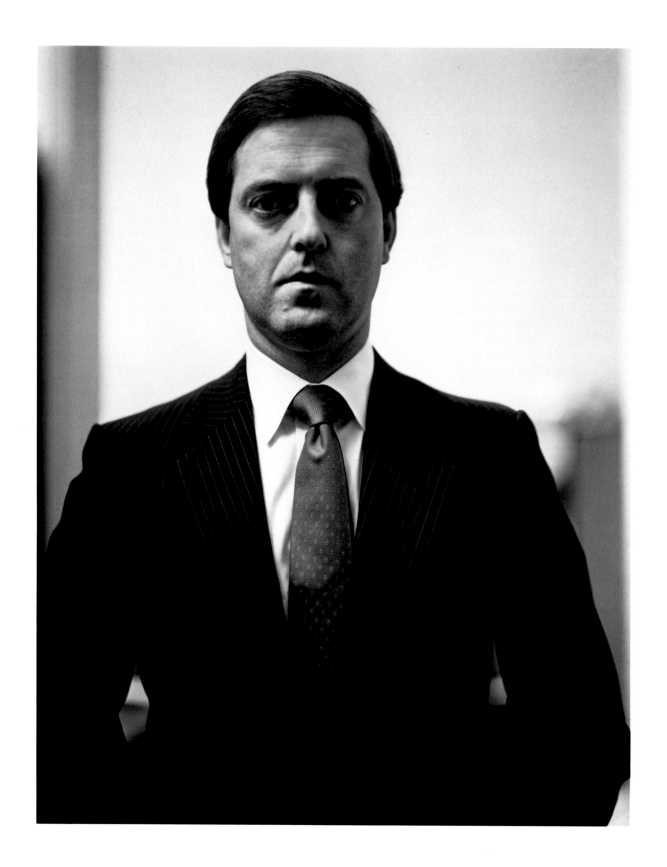

Congressman John P. Hiler, Republican, Indiana. 1987

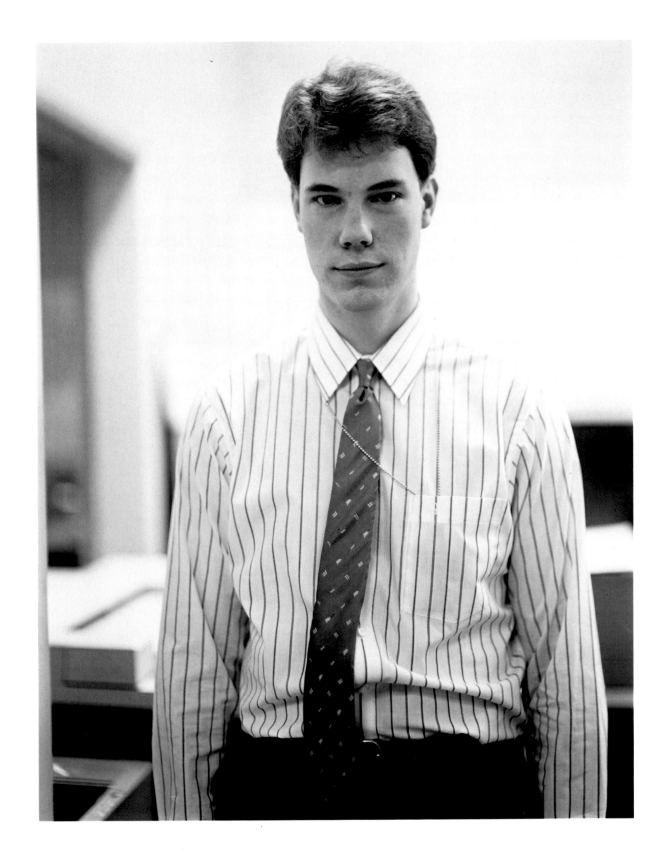

Scott Fillipse, Aide to Congressman James F. Sensenbrenner, Jr., Republican, Pennsylvania. 1987

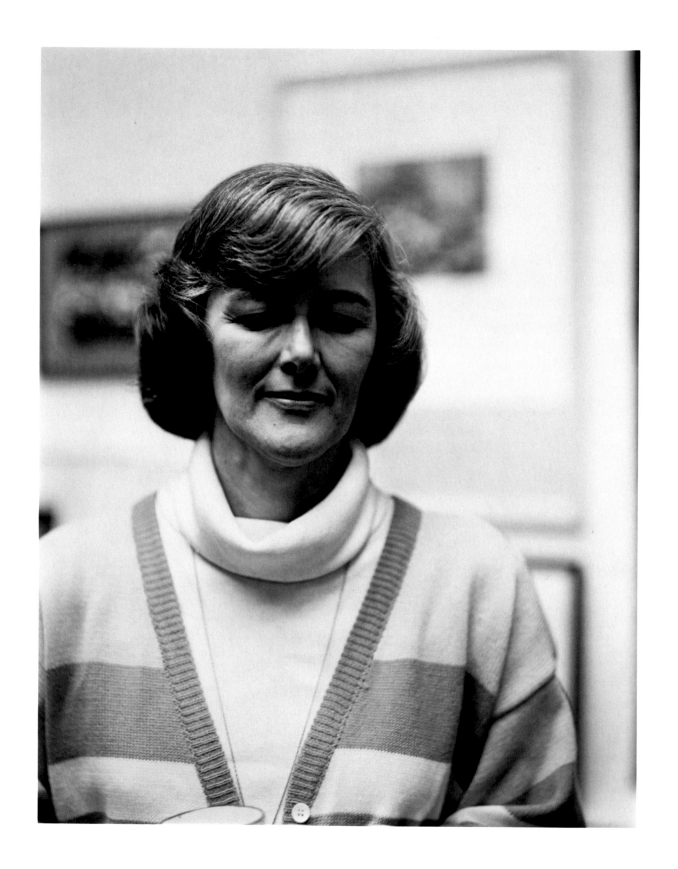

Congresswoman Pat Schroeder, Democrat, Colorado. 1987

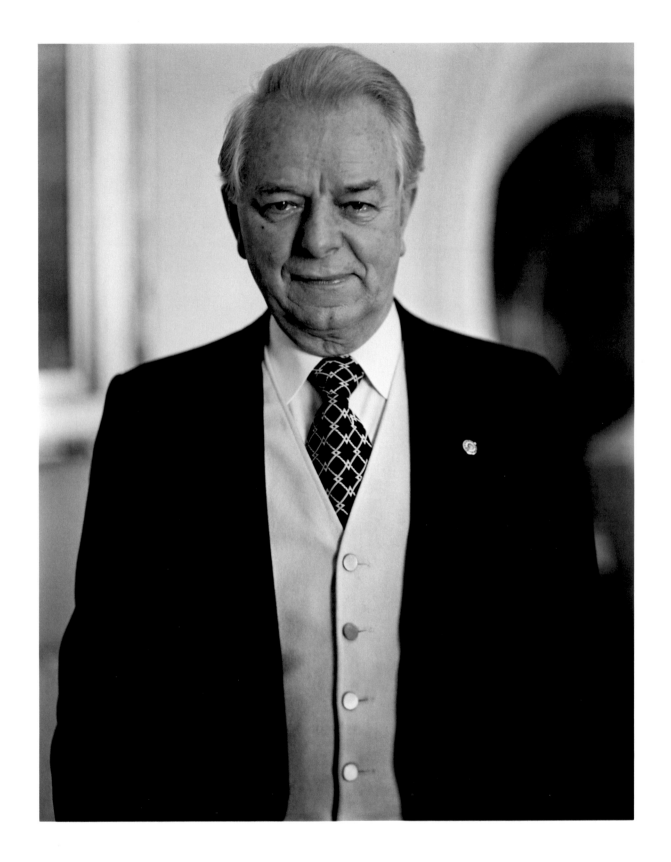

Senator Robert C. Byrd, Democrat, West Virginia (Majority Leader). 1987

Portraits, 1988 and 1990

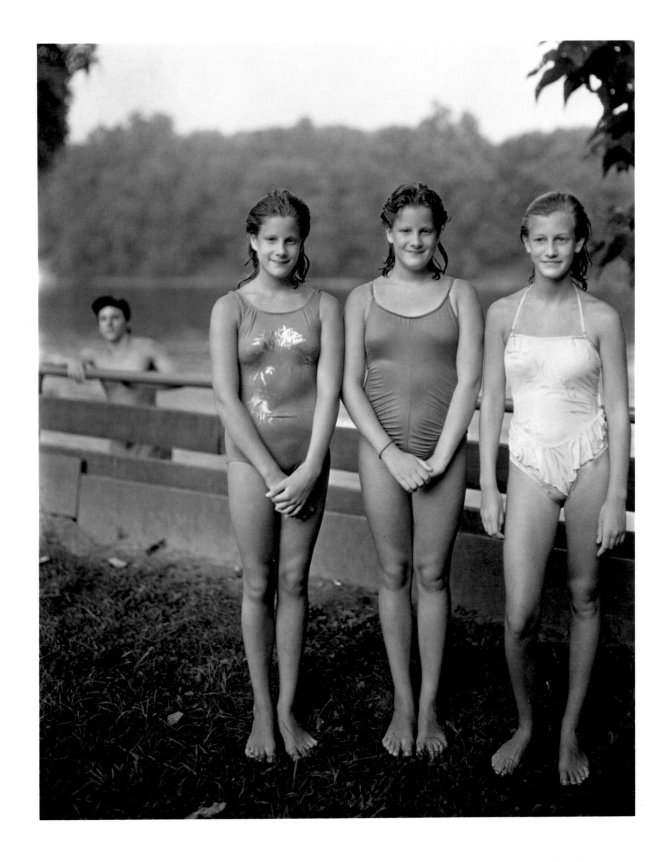

Untitled, from *Easton Portraits*. 1988

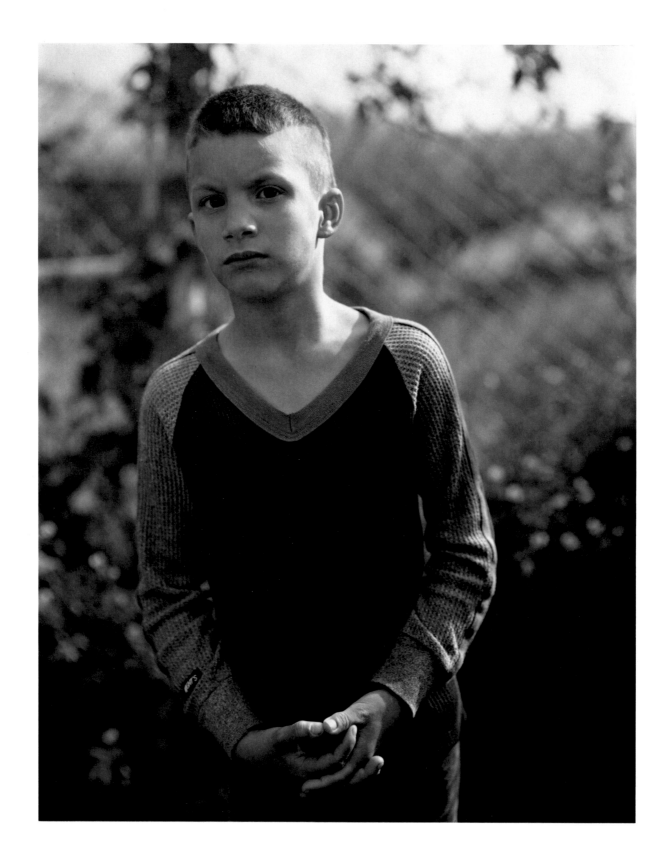

Untitled, from *Easton Portraits.* 1988

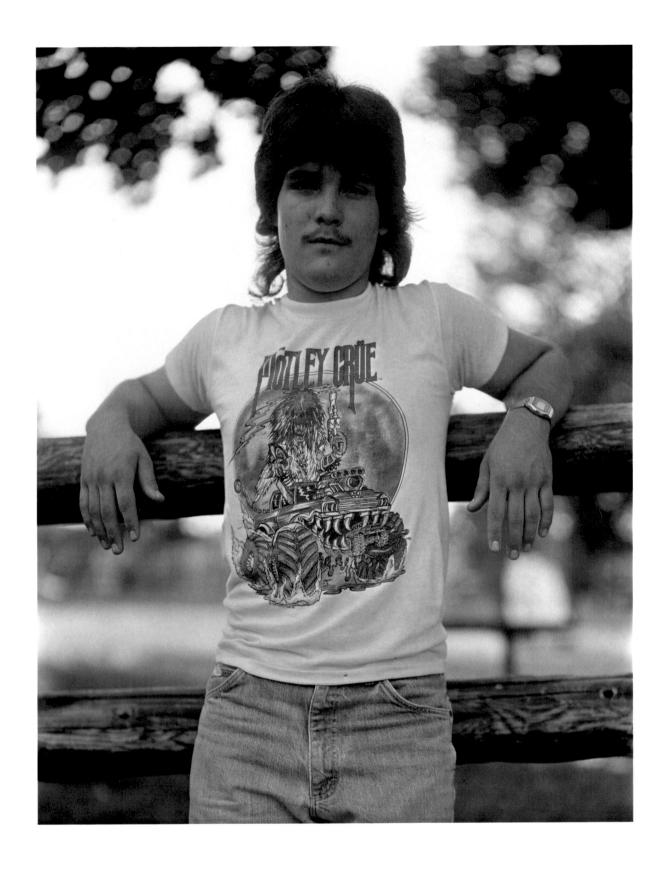

Untitled, from *Easton Portraits*. 1988

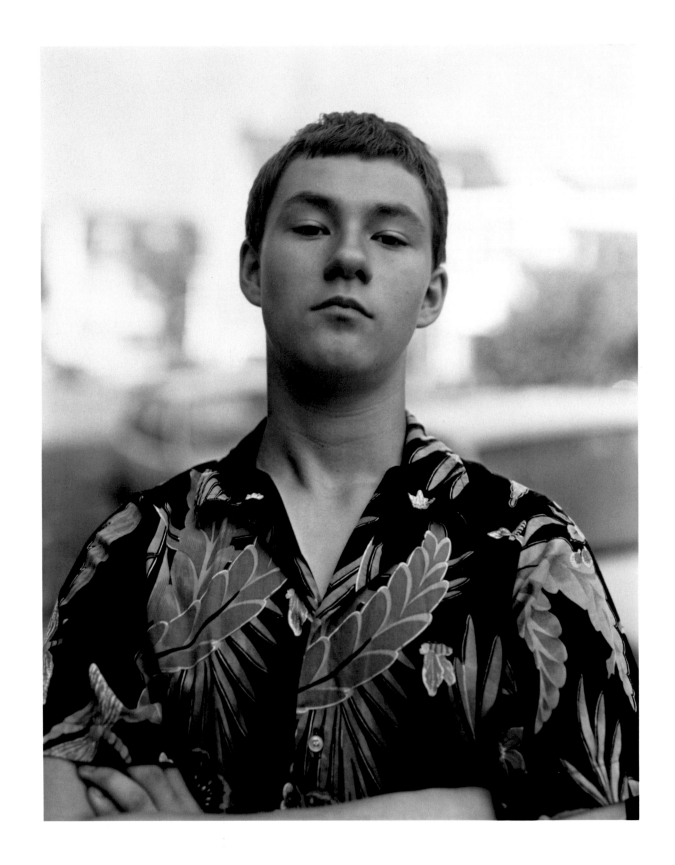

Untitled, from *Easton Portraits*. 1988

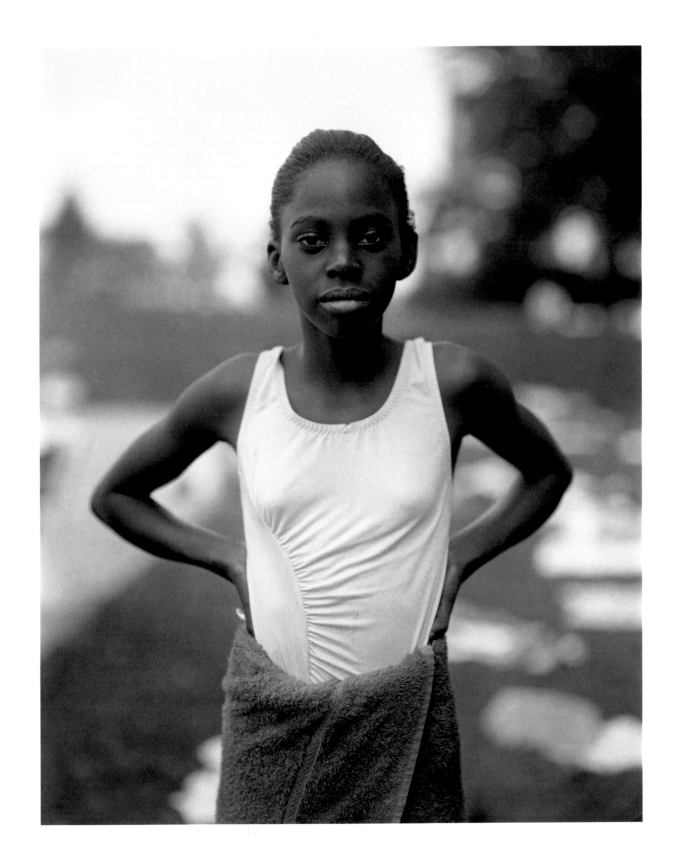

Untitled, from *Easton Portraits*. 1988

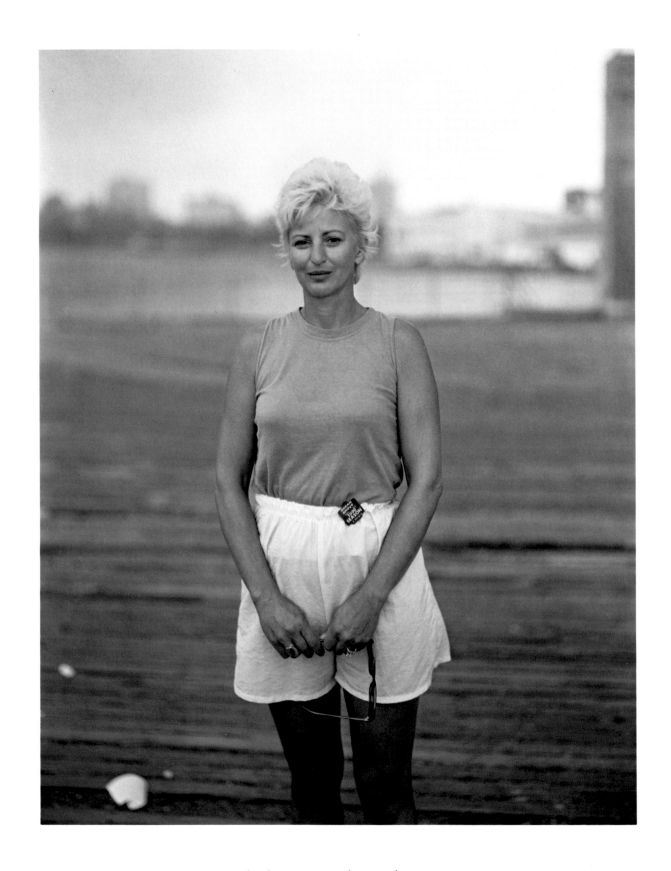

Blond Woman at Asbury Park. 1990

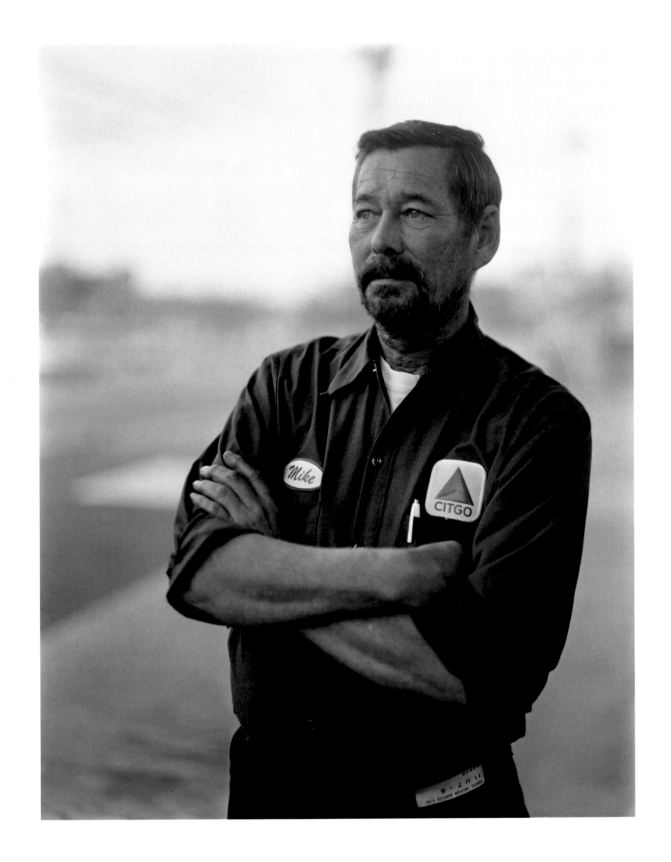

Mike, from *Jobs*. 1990

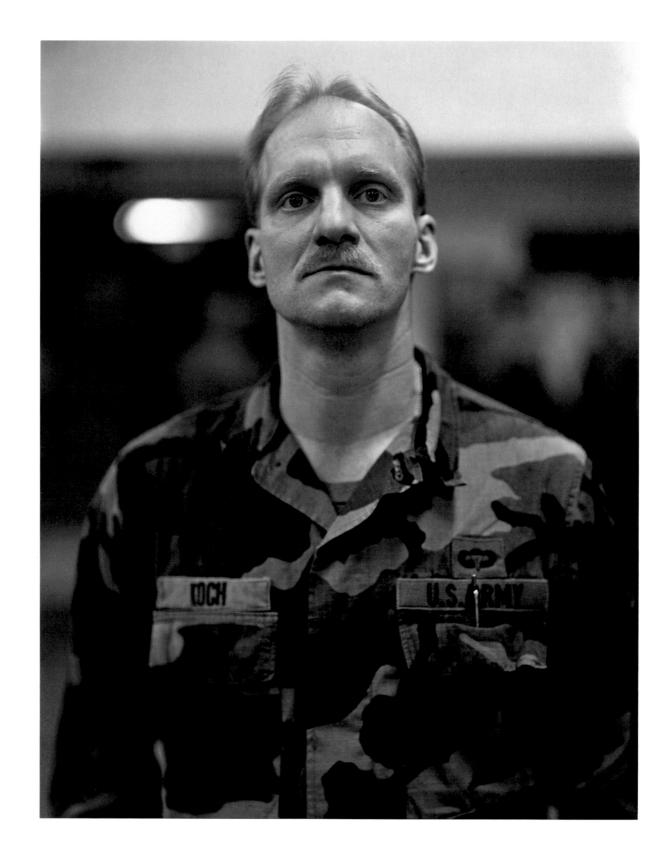

Staff Sergeant Richard T. Koch, U.S. Army Reserve, On Red Alert, Gulf War. 1990

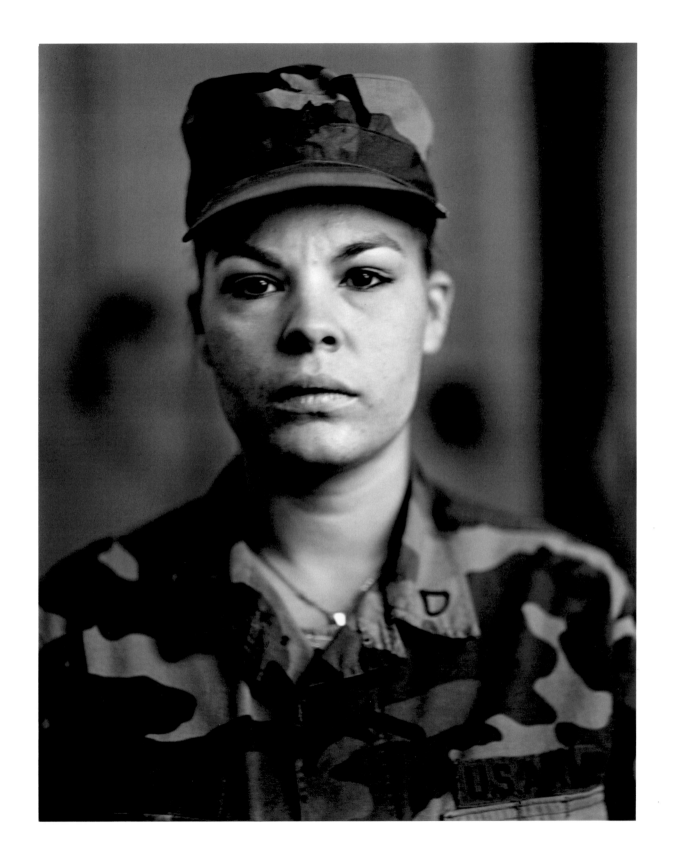

P.F.C. Maria I. Leon, U.S. Army Reserve, On Red Alert, Gulf War. 1990

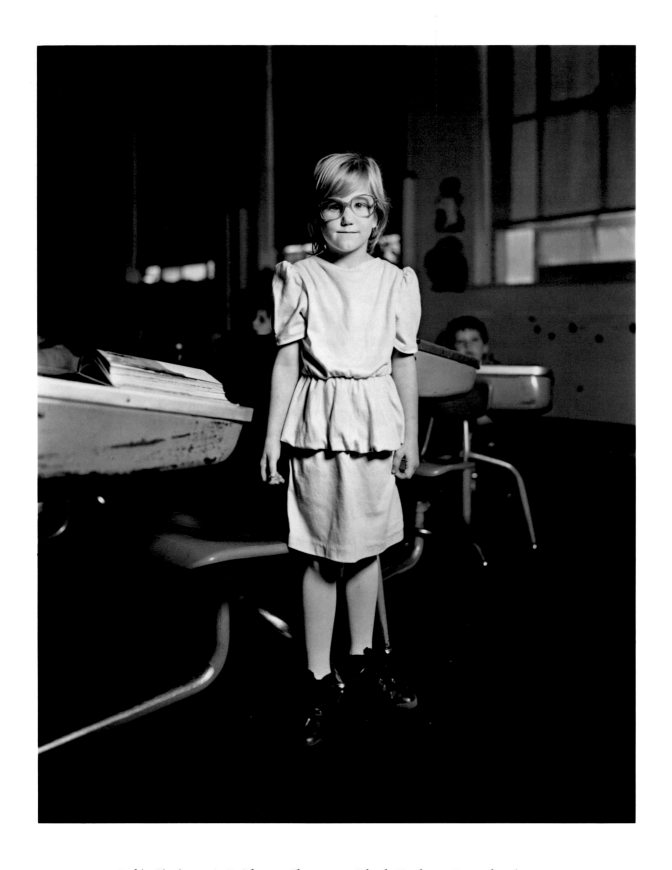

Jackie Cieniawa, A. D. Thomas Elementary School, Hazleton, Pennsylvania. 1993

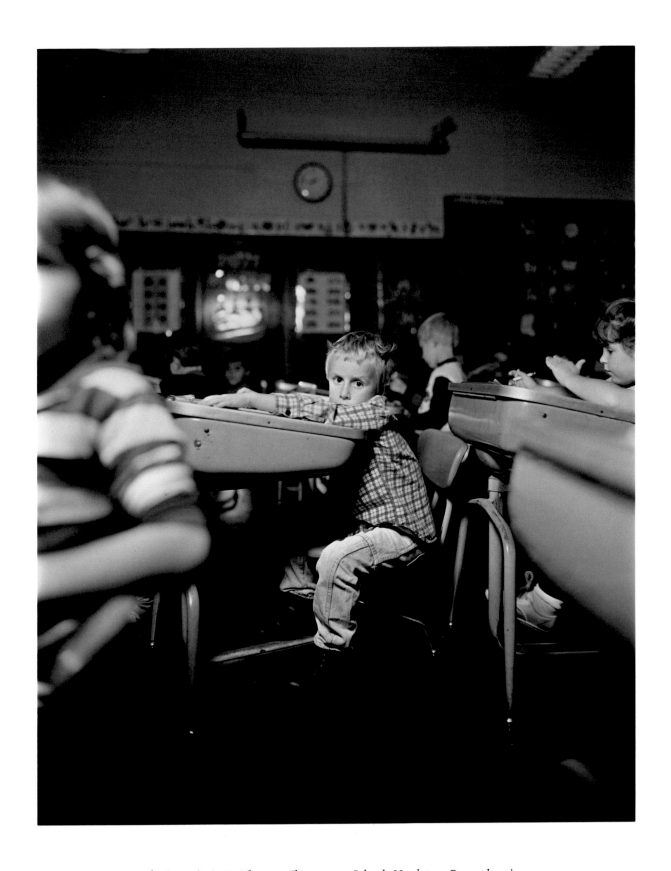

Randy Sartori, A. D. Thomas Elementary School, Hazleton, Pennsylvania. 1993

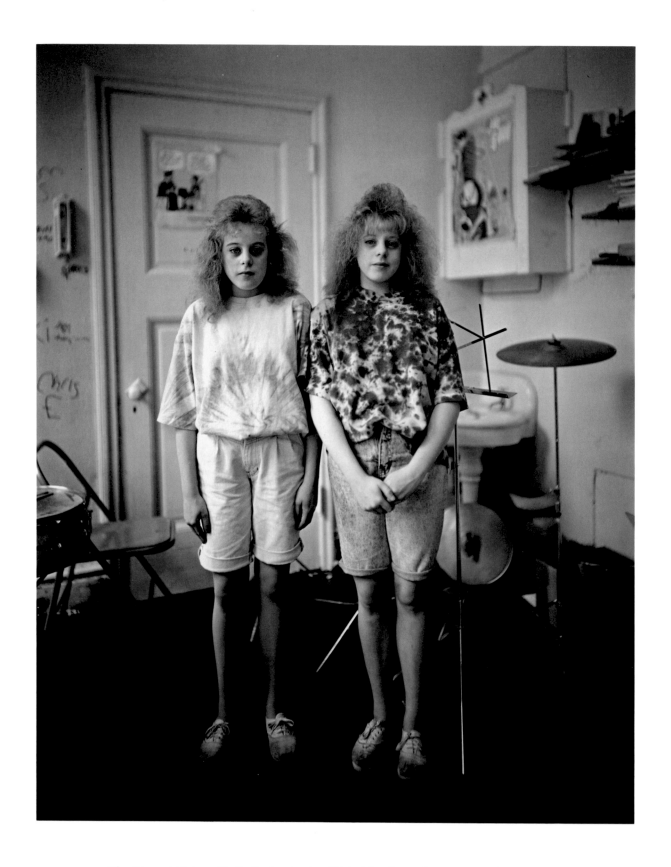

The Stewart Sisters, H. F. Grebey Junior High School, Hazleton, Pennsylvania. 1992

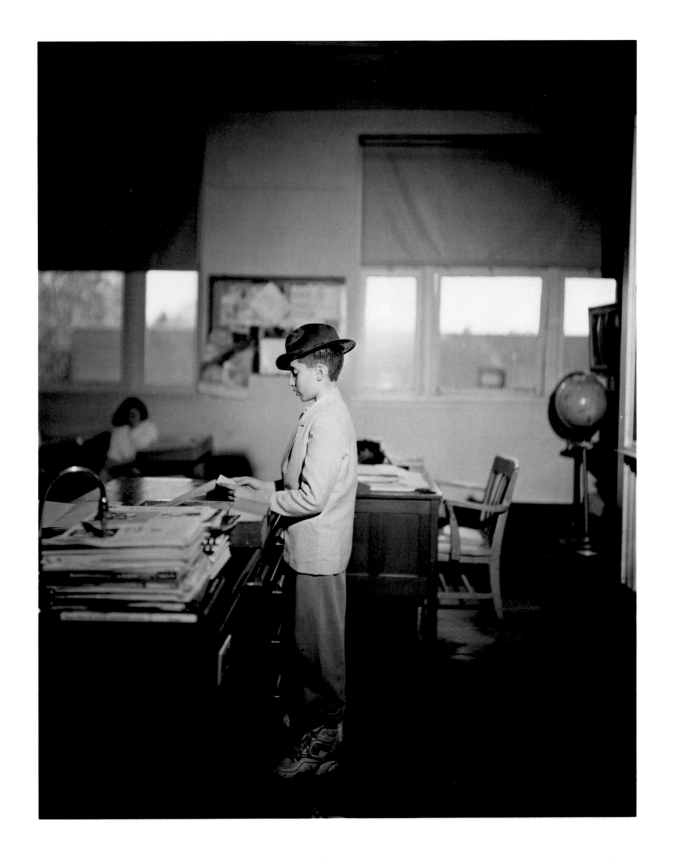

Brian Ellis Presenting a Lecture on the Mafia to Seventh Grade Class, H. F. Grebey Junior High School, Hazleton, Pennsylvania. 1992

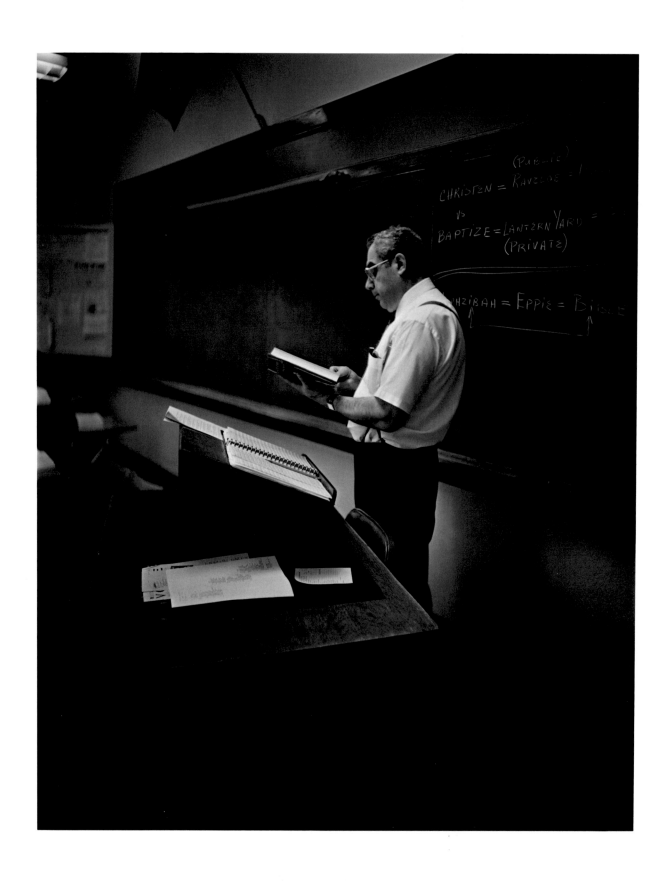

Robert Gaudio, English Teacher, Hazleton High School, Hazleton, Pennsylvania. 1992

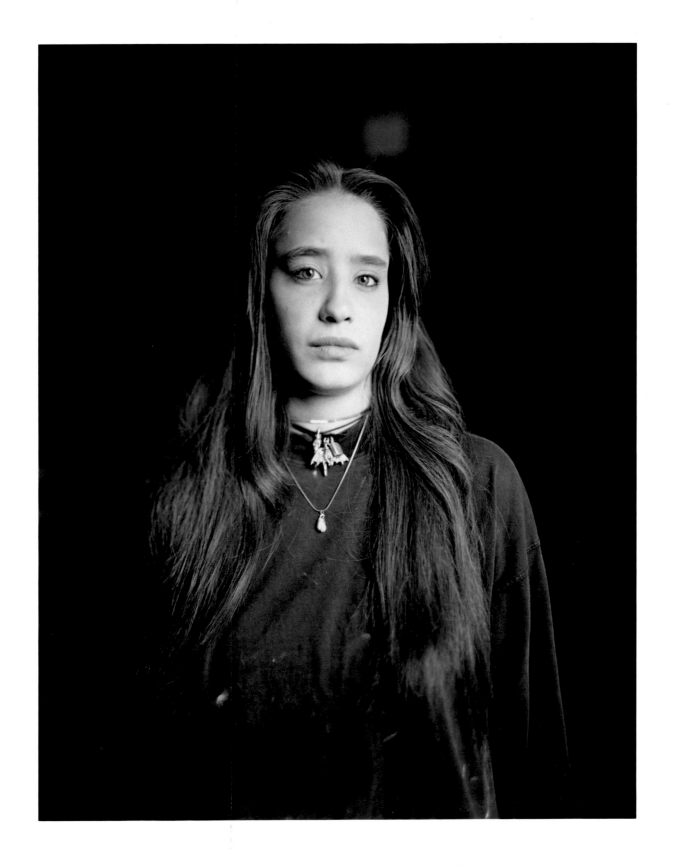

Casey Leto, Hazleton Area High School, Hazleton, Pennsylvania. 1994

Cleveland Public Schools. 1993

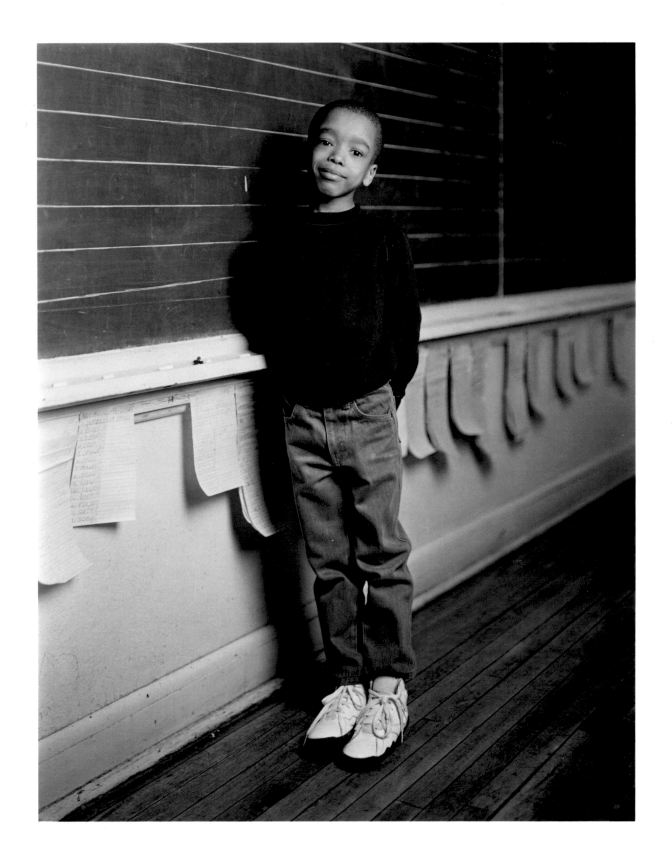

Brandon Brown, First Grade, Almira Elementary School, Cleveland, Ohio. 1993

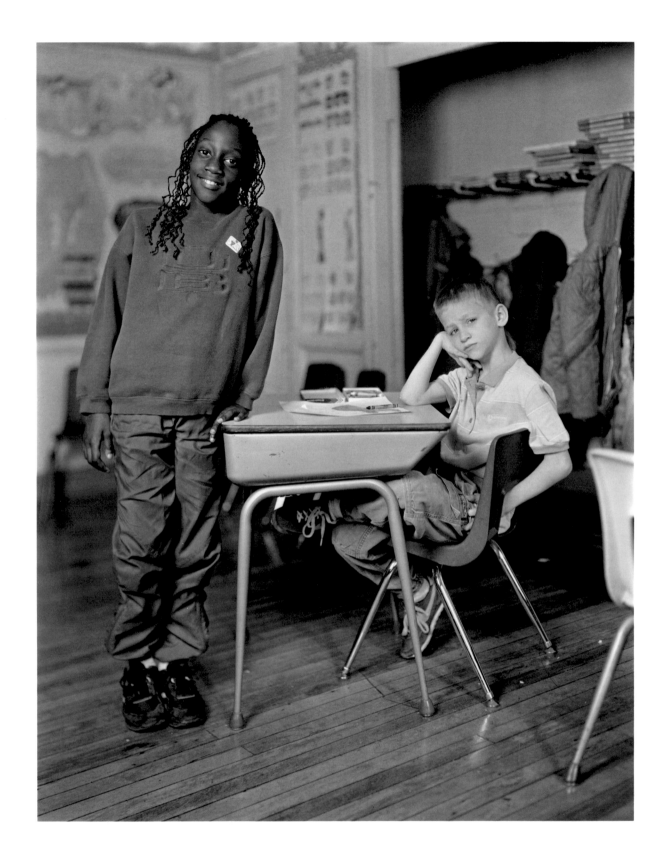

Cynthia Redding and James Gloeckner, Second Grade, Almira Elementary School, Cleveland, Ohio. 1993

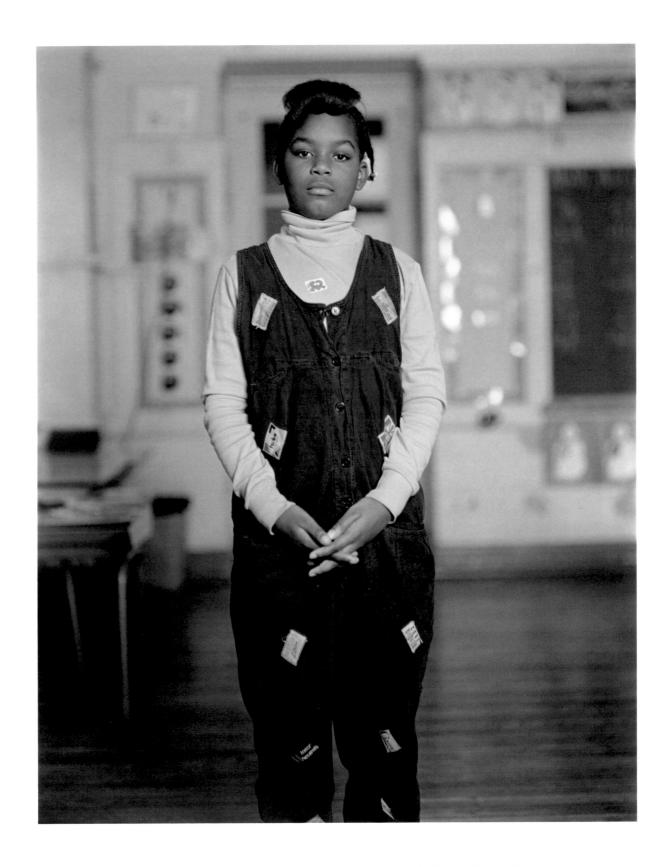

Carmen Williams, Second Grade, Almira Elementary School, Cleveland, Ohio. 1993

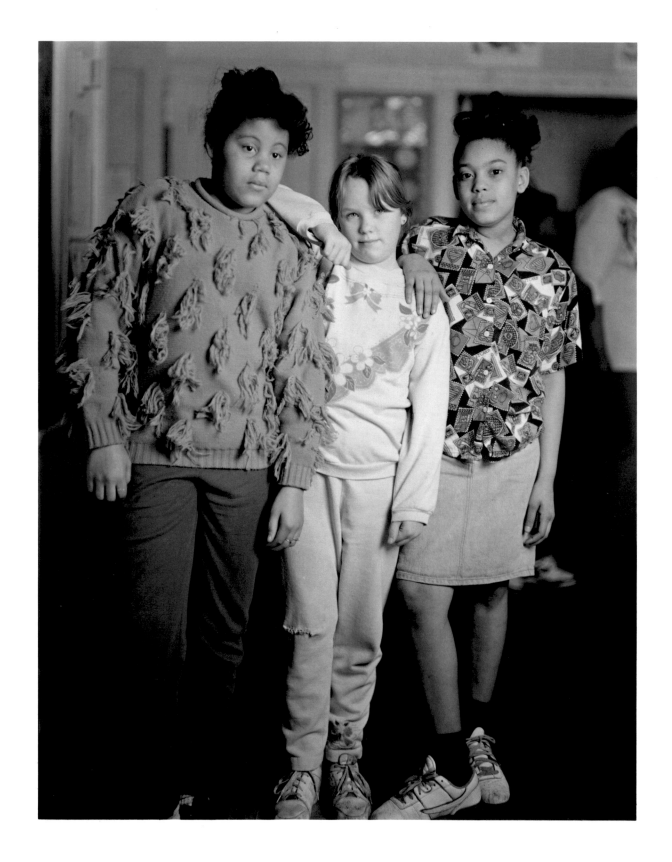

Kelly Griffin, Kimberly Proffitt, Tyra Lardell, Second Grade, Mrs. Gray's Class, Almira Elementary School, Cleveland, Ohio. 1993

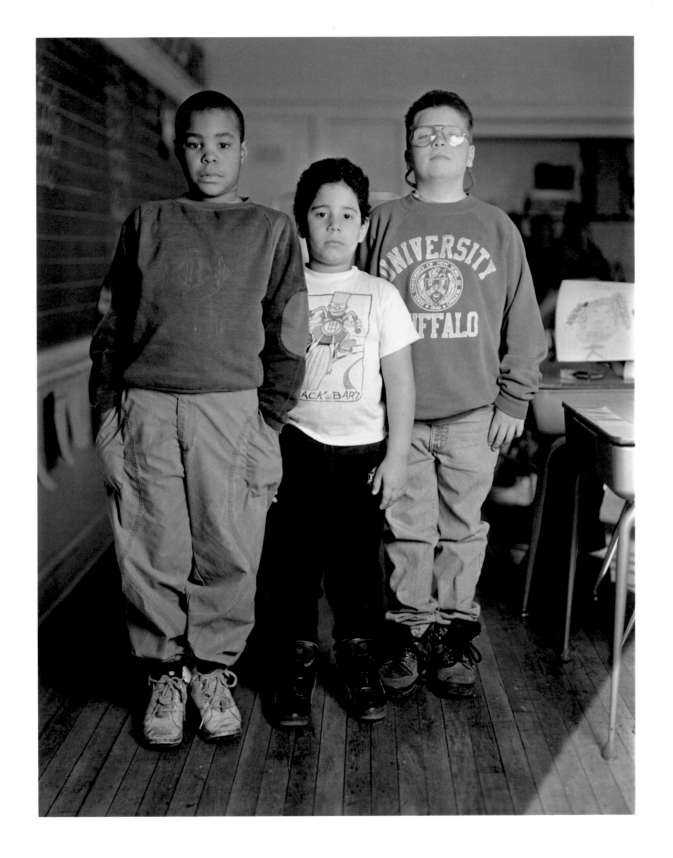

Cornelius McLean, Samuel Miranda, Matthew Jung, Second Grade, Mrs. Gray's Class, Almira Elementary School,
Cleveland, Ohio. 1993

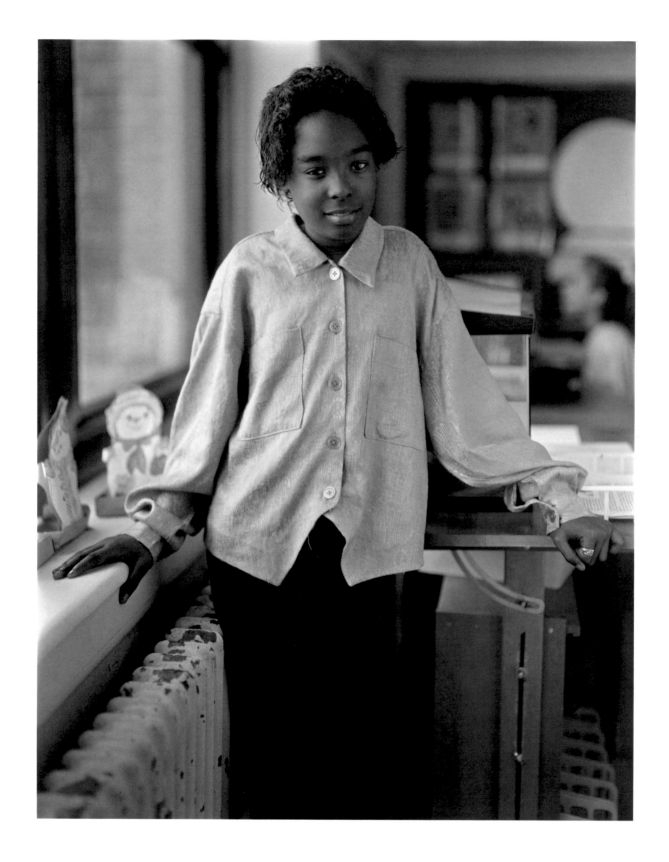

Toiya Phillips, Almira Elementary School, Cleveland, Ohio. 1993

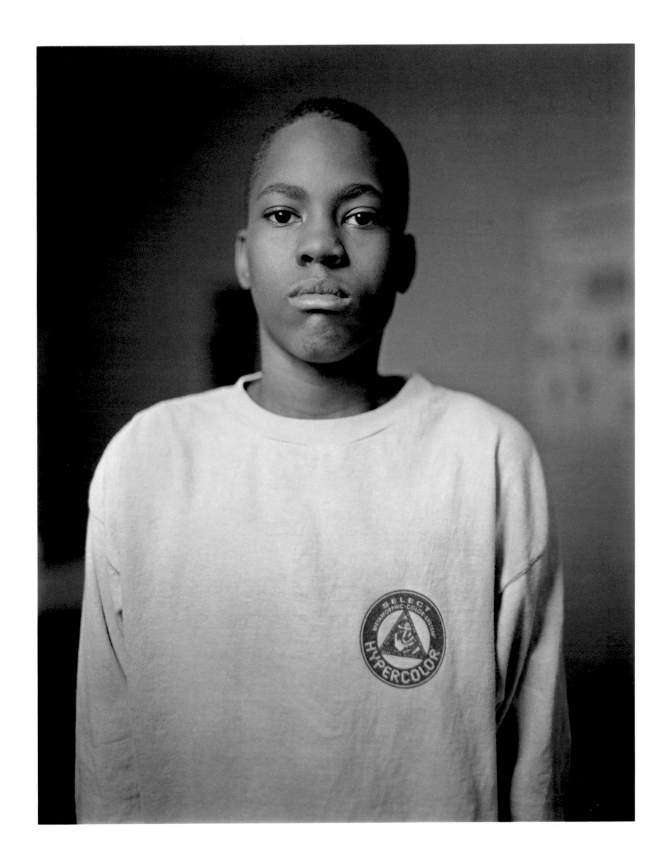

Le Shaun Franklin, Gallagher Junior High School, Cleveland, Ohio. 1993

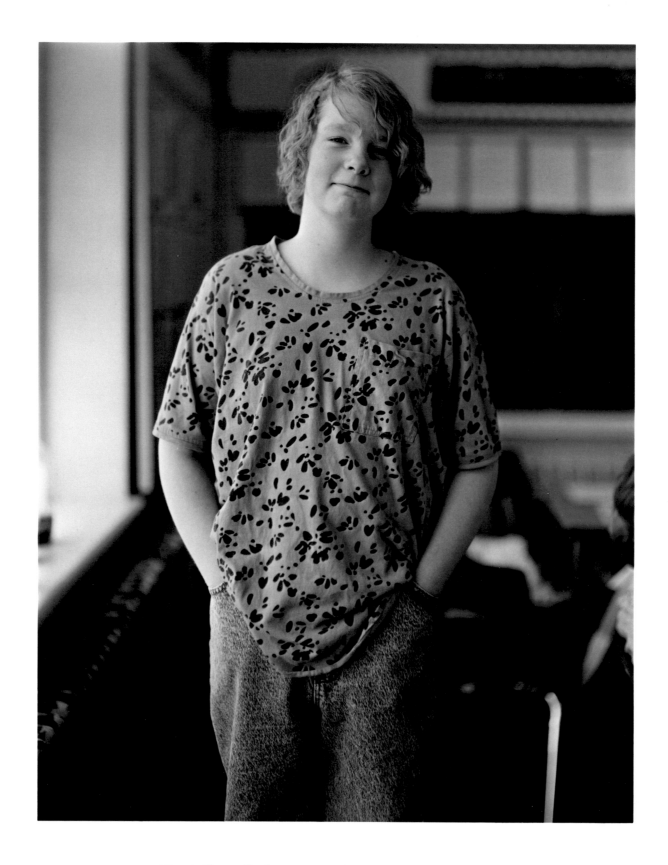

Nina Miller, Gallagher Junior High School, Cleveland, Ohio. 1993

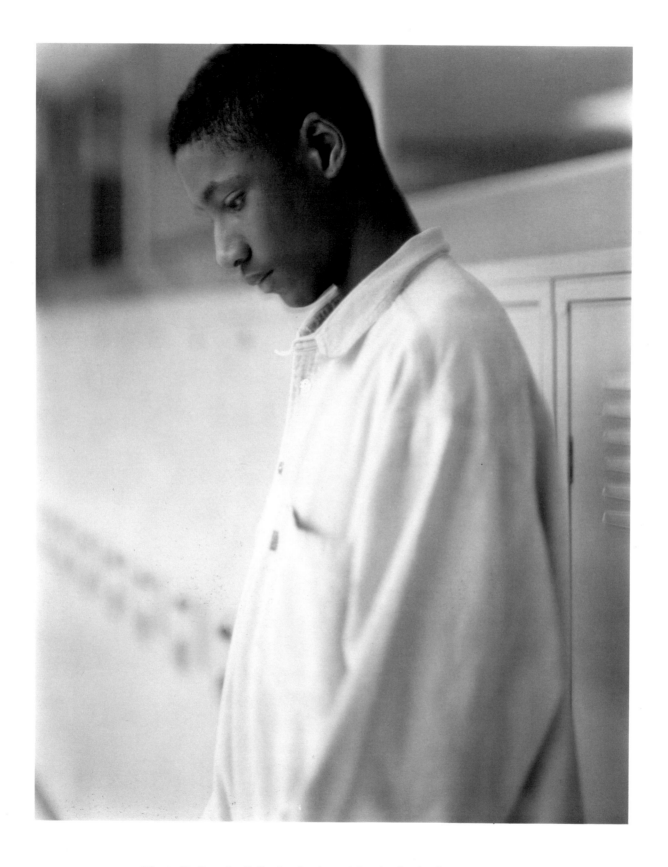

Dionte D. Dennis, Gallagher Junior High School, Cleveland, Ohio. 1993

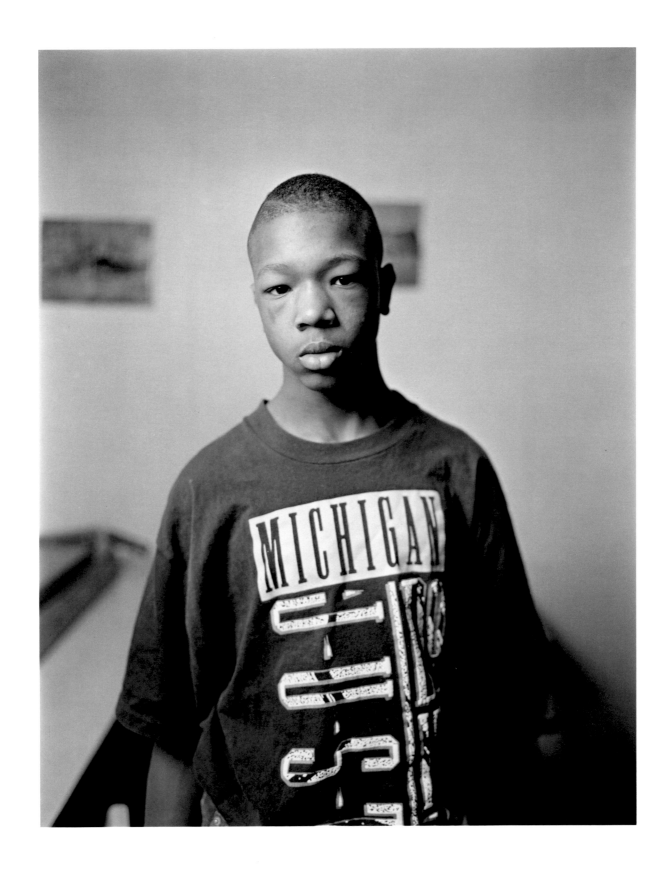

Robert Williams, Gallagher Junior High School, Cleveland, Ohio. 1993

Judith Joy Ross

Born August 12, 1946, in Hazleton, Pennsylvania
Resides in Bethlehem, Pennsylvania

Education

Institute of Design, Illinois Institute of Technology, Chicago, Illinois, M.S., 1970
Moore College of Art, Philadelphia, Pennsylvania, B.S., 1968

Fellowships and Grants

Pennsylvania Council on the Arts Grant, 1993
Charles Pratt Memorial Award, 1992
City of Easton/Pennsylvania Council on the Arts Grant, 1988
Artist Fellowship, National Endowment for the Arts, 1986
John Simon Guggenheim Memorial Foundation Fellowship, 1985

Individual Exhibitions

Portraits at the Vietnam Veterans Memorial, Washington, D.C., 1983–1984, James Danziger Gallery, New York (September 22–October 22, 1993)

New Work: Photographs by Judith Joy Ross, San Francisco Museum of Modern Art, San Francisco (September 16–November 28, 1993)

Judith Joy Ross/A Survey, James Danziger Gallery, New York (January 15–February 16, 1991)

Eurana Park, Weatherly, Pennsylvania, Laurence Miller Gallery, New York (December 7, 1989–January 27, 1990)

Portraits of the United States Congress, Lehigh University Art Galleries, Bethlehem, Pennsylvania (January 20–March 9, 1989)

Portraits of the United States Congress, Pennsylvania Academy of the Fine Arts, Philadelphia (July 2–August 30, 1987)

Judith Joy Ross, Allentown Art Museum, Allentown, Pennsylvania (December 2, 1984–February 24, 1985)

Selected Group Exhibitions

Pennsylvania Photographers 9, Allentown Art Museum, Allentown, Pennsylvania (February 3–April 9, 1995)

Warworks: Women, Photography and the Art of War, Victoria and Albert Museum, London (January 11–March 19, 1995)

American Politicians: Photographs from 1843 to 1993, The Museum of Modern Art, New York (October 6, 1994–January 3, 1995). Traveled to the San Francisco Museum of Modern Art, San Francisco (April 27–June 25, 1995) and the Corcoran Gallery of Art, Washington, D.C. (July 14–September 4, 1995)

The American Portrait, The Art Complex Museum, Duxbury, Massachusetts (May 6–July 10, 1994)

Photographs from the Real World, Lillehammer Art Museum, Lillehammer, Norway (November 13, 1993–January 23, 1994)

Magicians of Light: Photographs from the Collection of the National Gallery of Canada, National Gallery of Canada, Ottawa (June 4–September 6, 1993)

The Body in Nature, James Danziger Gallery, New York (June 3–July 2, 1993)

Observing Traditions: Contemporary Photographs 1975–1993, National Gallery of Canada, Ottawa (February 19–May 9, 1993)

Photographs from the Collection of Carlton Willers, University of Iowa Museum of Art, Iowa City, Iowa (January 16–March 7, 1993)

Pennsylvania Photographers 8, Allentown Art Museum, Allentown, Pennsylvania (January 15–March 21, 1993)

Representatives: Women Photographers from the Permanent Collection, Center for Creative Photography, Tucson, Arizona (September 6–October 18, 1992)

More Than One Photography: Works since 1980 from the Collection, The Museum of Modern Art, New York (May 14–August 9, 1992)

The Charles Pratt Memorial Award Exhibition, Center for Creative Photography, Tucson, Arizona (April 19–June 14, 1992)

Pennsylvania Photographers VII, Allentown Art Museum, Allentown, Pennsylvania (January 13–March 31, 1991)

The Indomitable Spirit, The International Center of Photography Midtown, New York (February 9–April 7, 1990). Traveled to the Los Angeles Municipal Art Gallery, Los Angeles (May 13–June 17, 1990)

Intentions & Techniques 1989: Selected Photographs and Recent Acquisitions from the Lehigh University Art Gallery, Lehigh University, Bethlehem, Pennsylvania (March 29–May 18, 1989)

Photography Until Now, The Museum of Modern Art, New York (February 14–May 29, 1989). Traveled to the Cleveland Museum of Art, Cleveland, Ohio (June 27–August 19, 1990)

Pennsylvania Photographers VI, Allentown Art Museum, Allentown, Pennsylvania (January 15–March 25, 1989)

Rethinking American Myths, Laurence Miller Gallery, New York (May 19–June 30, 1988)

Real Faces, Whitney Museum of American Art at Philip Morris, New York (May 6–July 7, 1988)

Recent Acquisitions: Photography, The Museum of Modern Art, New York (May 7–June 30, 1987)

Twelve Photographers Look at US, Philadelphia Museum of Art, Philadelphia (April 11–July 5, 1987)

Intentions & Techniques 1987: A Celebration, Lehigh University, Bethlehem, Pennsylvania (March 20–May 8, 1987)

Pennsylvania Photographers V, Allentown Art Museum, Allentown, Pennsylvania (January 11–March 1, 1987)

The Sensuous Image, Paul Cava Gallery, Philadelphia (November 29–December 24, 1985)

New Photography, The Museum of Modern Art, New York (August 22–December 3, 1985)

Intentions & Techniques 1985, Lehigh University, Bethlehem, Pennsylvania (March 1–April 18, 1985)

Pennsylvania Photographers III, Allentown Art Museum, Allentown, Pennsylvania (April 24–June 12, 1983)

Pennsylvania Photographers II, Allentown Art Museum, Allentown, Pennsylvania (April 19–June 7, 1981)

Intentions & Techniques 1979, Lehigh University, Bethlehem, Pennsylvania (November 2–December 2, 1979)

Books and Catalogs

Adams, Robert. *Why People Photograph*. New York: Aperture, 1994, pp. 102–104.

Alveng, Dag, ed. *Photographs from the Real World*. Oslo: The Cultural Program of the XVII Olympic Winter Games at Lillehammer and De norske Bokklubbene, 1994, pp. 52–62.

Borcoman, James. *Magicians of Light: Photographs from the National Gallery of Canada*. Ottawa: National Gallery of Canada, 1993, pp. 238–239.

Chahroudi, Martha. *Twelve Photographers Look at US*. Philadelphia: Philadelphia Museum of Art, 1987, pp. 6, 24–25. (Philadelphia Museum of Art Bulletin, vol. 83, nos. 354/355, Spring 1987)

Conklin, Jo-ann. *Photographs from the Collection of Carlton Willers*. Iowa City: University of Iowa Museum of Art, 1993, pp. 13–14.

Goldberg, Vicky. *Judith Joy Ross*. New York: James Danziger Gallery, 1991. (exhibition brochure)

Heiferman, Marvin. *The Indomitable Spirit*. New York: Harry N. Abrams, Inc., 1990, lot 15. (Sotheby's auction catalog)

Kozloff, Max. *Real Faces*. New York: Whitney Museum of Art at Philip Morris, 1988, pp. 5–9. (exhibition brochure)

Mott, Jacolyn A., ed. *Searching Out the Best*. Philadelphia: Pennsylvania Academy of the Fine Arts, 1988, pp. 162–163.

Phillips, Sandra S. *New Work: Photographs by Judith Joy Ross*. San Francisco: San Francisco Museum of Modern Art, 1993. (exhibition brochure)

Sullivan, Constance. *Women Photographers*. New York: Harry N. Abrams, Inc., 1990, plates 152, 153. (illustrations only)

Szarkowski, John. *Photography Until Now*. New York: The Museum of Modern Art, 1989, p. 312. (illustration only)

Williams, Val. *Warworks: Women, Photography and the Iconography of War*. London: Virago Press, 1994, pp. 56–59.

Selected Articles and Reviews

Aletti, Vince. "Ties That Bind: Judith Joy Ross Redefines Family." *The Village Voice*, vol. 36, no. 5 (January 29, 1991), p. 79.

_____. "Choices." *The Village Voice*, vol. 33, no. 33 (August 16, 1988), p. 41.

_____. "Choices." *The Village Voice*, vol. 33, no. 24 (June 14, 1988), p. 53.

Artner, Alan G. "The New View." *Chicago Tribune*, February 25, 1990, section 13, pp. 14–15.

Cerulli, E. Sheila. "In Search of Meaning: Photographer Judith Ross pursues truth." *The Express* (Easton, Pennsylvania), December 20, 1985, pp. D1, D10–11.

"City native's photos in Allentown exhibit." *Hazleton Standard-Speaker* (Hazleton, Pennsylvania), November 29, 1984, p. 29.

Gefter, Philip. "Interview with John Szarkowski." *Photo Metro*, vol. 8, no. 78 (April 1990), p. 20. (illustration only)

Grundberg, Andy. "Portraits Return in a New Perspective." *The New York Times*, June 26, 1988, section 2, p. 31.

_____. "The Modern Focuses on Contemporary Visions." *The New York Times*, September 15, 1985, section 2, p. 29.

Hagen, Charles. "Art in Review: The Body in Nature." *The New York Times*, July 9, 1993, p. C26.

_____. "Reviews, New York: Judith Joy Ross, James Danziger Gallery." *Artforum*, vol. 29, no. 8 (April 1991), p. 123.

Harlor, Betty. "Hazleton native exhibits at Museum of Modern Art." *Hazleton Standard-Speaker* (Hazleton, Pennsylvania), August 21, 1985, p. 35.

Hofammann, Albert. "Allentown Art Museum Marking Dual Milestones." *The Sunday Call-Chronicle* (Allentown, Pennsylvania), December 2, 1984, pp. F1, F8.

Hopkinson, Amanda. "Pieces of War." *The British Journal of Photography* (January 18, 1995), p. 24.

Hubbard, Sue. "Kensington Gore." *New Statesman & Society* (London), January 13, 1995, p. 33.

Kelleher, John. "Women and the Dogs of War." *The Times Educational Supplement* (London), January 27, 1995, part 2, p. 22.

Kerr, Peter. "The Ghosts of War." *The New York Times*, August 23, 1985, p. C1.

Levin, Eric. "Twelve Photographers Look at US." *People*, vol. 27, no. 20 (May 18, 1987), pp. 28–29.

Livingston, Kathryn. "We The People, In Philadelphia, a well-constituted national portrait." *American Photographer*, vol. 19, no. 1 (July 1987), pp. 30, 32 .

Maulfair, Jane. "Art Develops." *The Morning Call* (Allentown, Pennsylvania), September 1, 1985, pp. F1–2.

Novak, Ralph. "The Indomitable Spirit, by Photographers and Friends United Against AIDS." *People*, vol. 33, no. 13 (April 2, 1990), p. 29.

Perloff, Stephen. "Eurana Park, Judith Ross." *Photo Review*, vol. 8, no. 2 (Spring 1985), pp. 2–3.

Peterson, Brian. "Born in the U.S.A." *Afterimage*, vol. 15, no. 3 (October 1987), pp. 19–20.

Raczka, Robert. "Judith Joy Ross." *New Art Examiner*, vol. 15, no. 6 (February 1988), p. 62.

Rathbone, Belinda. "The Backyard (& Other Scenes of Virtuous Materialism)." *The Print Collector's Newsletter*, vol. 21 (November/December 1990), pp. 178–179.

Redd, Adrienne. "LV professor seeks out truth with a camera." *The Sunday Globe* (Bethlehem, Pennsylvania), September 1, 1985, pp. F1, F3.

Rubinstein, Meyer Raphael. "Real Faces: Struggling for the Soul of Photography." *Arts*, vol. 63, no. 3 (November 1988), pp. 72–75.

"Self and Shadow." *Aperture*, no. 114 (Spring 1989), pp. 20–21.

Sischy, Ingrid. "Goings on about Town: Photography." *The New Yorker*, vol. 66, no. 50 (January 28, 1991), p. 12.

Sorlien, Sandy. "Snap Judgments." *Philadelphia Daily News*, April 10, 1987, p. 72.

Sozanski, Edward. "Developments in Photography." *The Philadelphia Inquirer*, February 25, 1990, pp. J1, J6.

_____. "Faces of Power." *The Philadelphia Inquirer*, July 23, 1987, pp. D1, D5.

_____. "An Unsentimental Focus on America." *The Philadelphia Inquirer*, April 26, 1987, pp. H1, H16.

Trebay, Guy. "An Opinionated Survey of the Week's Events: New Photography." *The Village Voice*, vol. 30, no. 35 (August 27, 1985), pp. 64–65.

Welker, Janie. "Photography Until Now." *The Express* (Easton, Pennsylvania), April 13, 1990, p. D10.

_____. "Photos capture reality of kids: They're 'OK'." *The Express* (Easton, Pennsylvania), April 10, 1989, p. A7.

Williams, Val. "Women at War: New Tales from the War Zone." *Creative Camera*, no. 331 (December/January 1995), pp. 24–29.

compiled by Sarah Hermanson

A Note on the Prints

Judith Joy Ross uses an 8-by-10-inch view camera and makes printing-out paper prints. In this process, a contact print is made without an enlarger by placing the negative on photographic paper and exposing it to sunlight for a few minutes to a few hours. The prints, each measuring approximately 8 x 10 inches, are then toned with gold to bring out warm brown and gray tones.